Scams & Swindles

Phishing. Spoofing. ID Theft.
Nigerian Advance Schemes.
Investment Frauds.
False Sweethearts.

How to Recognize and Avoid
Financial Rip-Offs
in the Internet Age.

SILVER LAKE PUBLISHING
LOS ANGELES, CA • ABERDEEN, WA

Scams and Swindles

Phishing. Spoofing. ID Theft. Nigerian Advance Schemes. Investment Frauds. False Sweethearts. How to Recognize and Avoid Financial Rip-Offs in the Internet Age.

First edition, 2006
Copyright © 2006 by Silver Lake Publishing

Silver Lake Publishing
111 East Wishkah Street
Aberdeen, WA 98520
•
P.O. Box 29460
Los Angeles, CA 90029

For a list of other publications or for more information from Silver Lake Publishing, please call **1.360.532.5758**. Find our Web site at **www.silverlakepub.com**.

The Silver Lake Editors
Scams and Swindles
Includes index.
Pages: 276

ISBN: 1-56343-786-4

TABLE OF CONTENTS

1

IDENTITY THEFT

This book is about common financial swindles and scams directed at individual consumers. Most modern financial scams involve some form of identity theft. So, this is a good place to begin our story.

The Federal Trade Commission estimates that about 10 million Americans have their personal information stolen or misused in some way each year. This costs consumers $5 billion and businesses $48 billion—annually. More than half of all identity theft incidents occur in the banking industry, with about 33 percent involving credit card fraud.

And these numbers are estimates; they may not do justice to the scope of the ID theft problem. One important fact to remember: Identity theft can go on for months or even years after a data breach.

> Just because the police arrest a particular ID thief doesn't mean that all of his dirty business comes to light right away.

The critical elements of identity theft fall into five main categories:

1) businesses and institutions that don't take care of customer data;

2) data thefts of universities and other educational institutions;

3) the role of data brokers in the information economy;

4) the role of third-party processors of credit and debit card transactions;

5 the corruption of employees and insiders at big businesses or institutions.

CARELESS INSTITUTIONS

In March 2005, the DSW Shoe Warehouse chain announced that credit card information from customers of more than 100 of its stores had been stolen from a company database. DSW had been alerted to the leaks by a credit card company that noticed suspicious activity.

> Ironically, the information was stolen from a database of customers who made in-store purchases; Internet sales from the shoe retailer's Web site were not affected.

In April 2005, data stolen from the popular clothing retailer Polo Ralph Lauren forced banks and

credit card issuers to notify thousands of consumers that their credit card information had been exposed.

The same month, publisher and data broker Reed Elsevier Group admitted that up to 10 times as many people as originally thought had had their profiles stolen from one of its U.S. databases. The company had originally reported that intruders accessed personal details of 32,000 people via a breach of its Florida-based Seisint legal information unit. In fact, it admitted the figure was closer to 310,000 people. Information accessed included names, addresses, Social Security and driver license numbers.

> Ultimately, an internal investigation concluded that there had been 59 separate incidents at Seisint dating back to 2003. In each case, a crook stole the login information belonging to a legitimate Seisint customer and downloaded consumer Social Security numbers and other personal information.

Reed Elsevier had acquired Seisint (which provided data for Matrix, a crime and terrorism database project funded by the U.S. government that had raised concerns among civil liberties groups) less than a year earlier for $775 million.

Corporate America simply isn't as careful with consumer financial information as most consumers assume. Sloppy procedures for handling confidential data are repeated in many places. Some examples:

- In December 2004, Bank of America discovered that it had lost computer backup tapes with information on 1.2 million government workers (including U.S. senators and congressmen).

- In March 2005, TimeWarner Corp. announced that it had lost more than half a million detailed financial records for past and current employees.

- In May 2005, CitiFinancial—a unit of Citigroup—lost several shipping cartons filled with financial data on almost four million customers.

Crooks will sort through these corporate files and look for information they can use to steal identities.

Change of billing forms—known as *cobs*—are a hot commodity among ID thieves. A crook selling cobs is offering the freshest bank or credit card account information available.

ACADEMIC IDENTITY HEISTS

According to a 2005 report from California's Office of Privacy Protection, universities accounted for 28 percent of the major security breaches of personal information reported in the state between 2003 and 2005. That's more than any other group, including banks and financial institutions.

In March 2005, a crook walked into a University of California, Berkeley office and swiped a computer

laptop containing personal information on nearly 100,000 alumni, students and past applicants.

The laptop, which required a password to operate, had been left unattended for a few minutes in a restricted area of a campus office. A campus employee witnessed the theft and reported it to university police; they suspected that the thief was more interested in the computer than the data within.

> University officials waited several days to announce the crime, hoping that police would be able to catch the thief and reclaim the computer. When that didn't happen, the school publicized the theft to comply with a state law requiring consumers be notified whenever their Social Security numbers or other sensitive information have been breached.

About the same time, Boston College officials warned some 120,000 alumni that their personal information may have been stolen when an intruder hacked a school computer containing the addresses and Social Security numbers of BC graduates.

The compromised computer had been used to store names and phone numbers of graduates for the purpose of soliciting donations.

BC sent letters that urged alumni to protect their identities and financial accounts by contacting their banks and warning them that their Social Security numbers may have been stolen.

These academic breaches pose a much bigger problem that most sophomore Poli Sci majors realize.

In April 2005, the National Science Foundation announced that a consortium center for security experts from American colleges and universities would be based at the University of California—with the mission of keeping the nation's computer data safe from cyberattack.

The consortium, called the Team for Research in Ubiquitous Secure Technology (TRUST), was expected to receive nearly $19 million in funding over five years. Berkeley would be joined by Carnegie Mellon University, Cornell University, Mills College, San Jose State University, Smith College, Stanford University and Vanderbilt University. A number of businesses also would be affiliated with the project—including Microsoft Corp., Hewlett Packard Co., IBM Corp. and Symantec Corp.

TRUST researchers would explore technology that could help organizations build secure information systems. The organizations clearly need this.

THE ROLE OF DATA BROKERS

A consumer reporting agency (CRA) gathers and packages personal information into consumer reports which they sell to creditors, employers, insurers and other businesses. The best-known CRAs are major credit bureaus—such as Equifax, Experian and TransUnion; their business is regulated by the Fair Credit Reporting Act (FCRA).

Data brokers (also known as *data aggregators*) are the less-reputable corporate cousins of CRAs. Brokers collect information (from public records, criminal databases and other sources) and package it into reports that they sell to businesses—as well as local, state, and federal government agencies.

> **These reports can be intended to provide background information on specific people...or they can be for "marketing" of direct sales materials to groups.**

An important fact: Some, but not all, of data brokers' activities fall under the FCRA. As a result, they are not regulated as closely as CRAs are.

ChoicePoint Inc., based near Atlanta, Georgia, is one of the largest data brokers in the world. Its business is to gather information on consumers, "warehouse" that information in proprietary databases...and sell the information to corporations that make consumer credit decisions on everything from insurance premiums to home mortgages.

In February 2005, ChoicePoint admitted that identity thieves—who'd operated undetected for more than a year—opened up 50 corporate accounts and received vast amounts of data on some 145,000 consumers nationwide.

The company said that consumers in all 50 states, the District of Columbia and three U.S. territories may have been affected by the breach of its corporate security measures.

It also announced plans to "rescreen" some 17,000 corporate customers to make sure they were legitimate. And, even once rescreened, those companies would no longer have access to consumers' Social Security numbers, dates of birth and driver's license numbers—unless sponsored by a public company or government agency.

This was the first time that ChoicePoint had admitted how much personal data it had.

Other steps ChoicePoint took in the wake of the security breach:

- it hired a former Secret Service agent to help revamp its verification process;
- it notified all of the potential victims by mail—following the state of California's law, even in other states;
- it planned to "remove information in those segments where organized crime fraud is likely to occur."

Many of the consumers who received the letters from ChoicePoint had never heard of the company before...and didn't understand how it had come into possession of so much of their personal data.

What exactly had happened?

The thieves operated in an organized ring, based in southern California and apparently headed by a Nigerian immigrant named Olatunji Oluwatosin. The ring used stolen identities to create what appeared to be legitimate businesses seeking ChoicePoint merchant accounts. They posed as

check-cashing companies or debt collection firms and provided business licenses that appeared to be legitimate and used the names of real people with clean criminal records.

Like any business that opens an account with ChoicePoint, the thieves' bogus companies were given access codes and passwords that allowed them to use ChoicePoint's databases. Then, they accessed volumes of data on consumers—including names, addresses, Social Security numbers and credit reports.

They used this information to set up "clones"— financial duplicates of real people—and use those to run various money scams.

ChoicePoint started to suspect something was wrong in the fall of 2004 when it received a faxed application for a corporate account from a Kinko's in southern California. So, working with the local sheriff's department, it sent a response requesting a new signature. Deputies who'd staked out the copy store arrested Oluwatosin a short time later.

Oluwatosin was charged with six felony counts of fraud. But he denied that he headed any criminal organization and insisted that he was just a dupe doing some clerical work for others.

In February 2005, Oluwatosin pleaded "no contest" to a single count of ID theft. He was sentenced to 16 months in state prison and ordered to pay a small fine. The other charges against him were dropped.

In June 2005, the Internal Revenue Service announced that it had awarded a $20 million contract to ChoicePoint. The arrangement allows IRS auditors and criminal investigators to use ChoicePoint's databases to locate assets owned by delinquent taxpayers.

> **This is one of the dirty secrets of the data brokerage business: Government agencies are some of the brokers' biggest customers. This can make government oversight of the brokers...conflicted.**

A GRAY MARKET

Even defining the term "data broker" is difficult. Most brokers sell people's personal information to third parties. In some cases, this occurs with the person's knowledge—such as when you apply for a new credit card or mortgage. In other cases, data brokers get involved in transactions that wouldn't seem to require personal financial information—like buying retail items for cash.

Data brokers have operated under a self-regulatory scheme, known as the Individual Reference Service Group (IRSG) Principles. Through these principles, the broker industry allows members to sell detailed data to almost anyone for almost any purpose. The IRSG Principles allow brokers to choose who is a "qualified" buyer of personal information.

A research paper on the topic of data brokers released in May 2005 (and titled "A Study of Data

Quality and Responsiveness") put the problems in start terms:

> *100% of the reports given out by ChoicePoint had at least one error in them. Error rates for basic biographical data (including information people had to submit in order to receive their reports) fared almost as badly: Acxiom had an error rate of 67% and ChoicePoint had an error rate of 73%. In other words, the majority of participants had at least one such significant error in their reported biographical data from each data broker.*

> *...The extremely high error rates for both companies and Acxiom's lack of responsiveness indicates the likelihood that these problems are likely to occur on a broader scale. The results clearly point out the need for a larger study on the critical issues of data broker accuracy and responsiveness.*

That same month, with the U.S. Congress contemplating various plans for regulation data brokers, executives from the industry's biggest players testified about how hard they worked to protect consumers. Among these executives, Jennifer Barrett—the Chief Privacy Officer for Acxiom Corp. (a major ChoicePoint competitor)—made the most aggressive defense of the industry. She said:

- Acxiom does not maintain one big database that contains information about all people. Instead, the company has discrete databases developed to meet the specific needs of its clients—entities that are appropriately screened and with whom Acxiom has legally enforceable contractual commitments.

- Acxiom does not provide information on particular individuals to the public, with the exception of Acxiom's telephone directory products. These products, which are available on several Internet search engines, contain information already available to the public.

- Acxiom's fraud management products are sold exclusively to a handful of large companies and government agencies-they are not sold to individuals.

- Acxiom's verification services only validate that the information clients have obtained from consumers is correct.

- Acxiom's background screening products provide employment and tenant screening services which utilize field researchers who do in-person, real-time research against public records. Where permitted by law, a pre-employment credit report can also be obtained.

Notice that many of the most important terms Barrett used—"appropriately screened," "contractual commitments," etc.—are standards that companies like Acxiom set for themselves through the IRSG Principles.

CORRUPTION OF INSIDERS

While people generally think of outsiders—such as malicious computer hackers—as the main data security risk, security experts agree that dishonest employees are *the* major security problem.

Philip Cummings worked as technical support representative for Teledata Communications, a software company based in suburban New York. The company provides banks with computerized access to credit information databases; Cummings wasn't a high-level employee and he didn't even work at Teledata long—a little more than year between the summer of 1999 and fall of 2000.

But he did a lot of damage.

According to federal prosecutors, Cummings agreed to sell an unidentified coconspirator passwords and codes for downloading consumer credit reports. Tens of thousands of credit reports were stolen; Cummings was paid roughly $30 for each one.

> The stolen IDs were passed on to at least 20 individuals who then supplied a network of criminals nationwide.

Federal agents were able to locate the Teledata breach and identify Cummings from their first broad investigations of identity theft—which started after the September 2001 terrorist attacks in New York and Washington, D.C.

Like other crooks before him, Cummings tried to argue that he was merely a low-level dupe who didn't completely understand what he was doing. But the Feds didn't buy his arguments. In September 2004, he pleaded guilty to conspiracy, wire fraud and fraud in connection with identification documents.

In January 2005, Cummings was sentenced to 14 years in prison by a judge who said the damage the former help desk employee had caused was "almost unimaginable."

Obscure companies like Teledata aren't the only ones susceptible to employee corruption.

In April 2005, police in Hackensack, N.J., arrested eight employees at Bank of America, Wachovia, PNC and Commerce Bank for selling account data to an unlicensed collection agency. The operation snared data on more than 676,000 people, including customers from six other banks.

ARE PEOPLE EVEN AWARE?

There's an exposure that may be even larger than data brokers.

Every time you use a credit card or debit card, several financial institutions are involved in verifying and authorizing the transaction—and only one of them is the institution whose name is on your card.

In most cases, a merchant who is taking your card for payment will use an independent, third-party electronic payment processor to handle the charge. This third-party processor is in touch electronically with the institution whose name is on your card.

The processor contacts that institution, make sure the card is active and valid, makes sure there are

funds or credit available to cover the charge and authorizes the purchase.

In most cases, a day or two later, it receives the money from the card issuer and transfers the money into the bank account of the merchant who sold you the item. For doing all of this, the third-party processor takes a fee from the merchant.

The whole business is loosely regulated, since third-party processors aren't banks or other institutions with fiduciary responsibility to you. Most of the card transaction business is defined by contracts between the processors and the institutions that issue cards (consumers are usually an afterthought in these deals) rather than laws or regulations.

According to some insiders, the third-party processor industry sprung up precisely to get around the fiduciary and due diligence laws and regulations that apply to financial institutions.

While there are only a handful of major data brokers, there are dozens of third party processors.

In June 2005, one of these—an Atlanta-based company called CardSystems Solutions, Inc.—announced that it had made a big mistake.

CardSystems had kept detailed files on most of the card transactions that it has processed over several years. The privately held company processed some

$15 billion in card transactions a year; so, it had personal data related to some 40 million Discover, Visa, MasterCard and American Express cards.

Some time in late 2004 or early 2005, a gang of hackers broke into CardSystems computer network. Gradually, over a period of weeks or months (CardSystems didn't release details—and may not have *known* the details), the hackers downloaded data on millions of cards.

In all, the hackers got into databases that contained data on 22 million Visa cards, 13.9 million MasterCard cards and over four million cards of other brands.

CardSystems CEO John Perry said that his company had kept the data "for research purposes." But keeping this data was a direct violation of various agreements that CardSystems had—including agreements with Visa, MasterCard and other card brands which allowed it to operate as an "authorized" processor.

CardSystems said that its internal investigation concluded that details on only about 200,000 cards had been downloaded.

Mastercard made a point of saying that no highly sensitive personal information—such as Social Security numbers—were exposed in the breach.

Within days, Visa USA Inc. said it was cutting ties with CardSystems. According to Rosetta Jones, a

Visa vice president, CardsSystems "has not corrected, and cannot at this point correct, the failure to provide proper data security for Visa accounts."

For most people in the bank card industry, this was the most frightening thing about the CardSystems breach: The company had no way to measure the problem. Its network security systems were so shoddy that *no one* might ever know precisely how much card data had been stolen.

SKIMMING

As many experts noted, the CardSystems hack was a high-tech version of skimming...which is usually a rather low-tech element of identity theft.

> When a credit card is skimmed, the cardholder's name, account number and security code are scanned, stored and later distributed to crooks—who use the information to create counterfeit cards or begin building financial clones.

In most cases, skimming is done by low-level clerks and service-providers—retail employees, waiters/waitresses, telephone sales reps, etc. These people are usually working informally for an identity thief and are paid a small amount (from $10 to $100, depending on the details they get) for each card number they take.

Sometimes, the mechanics of the skim can be as simple as making a manual card receipt on carbon

paper; other times, the identity thief will give the clerk a data-storage device that looks something like an old-fashioned pager. The clerk will casually slide cards through a digital scanner built in the device.

Skimming is a numbers game. The crooks want to get as many credit card numbers as they can, so that their underworld customers can run frauds on as many cards as possible.

Databases at data brokers and third-party card processors are the biggest numbers around.

WHAT CAN BE DONE?

What drove all of the data theft disclosures in 2005? A little-known California state law.

Until 2004—when California enacted the first law of its kind in the U.S.—merchants and third-party processors weren't required to disclose breaches that exposed consumers' personal information. Breaches were rarely, if ever, reported publicly.

Since large companies do business in more states than California, complying with the California law forces their hand to alert consumers in every state.

Chris Hoofnagle, Senior Counsel to the Electronic Privacy Information Center, suggests that better regulations could help individuals take back more control of their financial data. Specifically, Hoofnagle supports:

...legislation that will prevent identity theft by allowing individuals to "freeze" their credit. Under these proposals, individuals can erect a strong shield against identity theft by preventing the release of their credit report to certain businesses. Because a credit report is always pulled before a business issues a new line of credit, a freeze will make it very difficult for an impostor to obtain credit in the name of another person.

ONLINE BANKING MAY HELP

Many people think of the Internet as an exposure to ID theft. But managing your personal accounts online may be a good way to minimize the exposure; it can help you recognize problems quickly.

Consumers who spot fraud online suffer an average theft of about $500; those who wait for paper records and suffer ID theft suffer average losses of $4,500.

> Despite the high-tech anecdotes, personal financial data is usually stolen in off-line ways—such as going through trash (what security experts call "dumpster diving") and simple theft of purses or wallets—rather than over the Internet. And, when data is stolen online, it's usually stolen by insiders.

So, any company that takes your personal financial information (your address, Social Security number,

credit information, etc.) should have a clearly-defined data management structure that follows what security professionals call The Four A's:

1) authentication,

2) authorization,

3) administration and

4) audit.

The company should be able to explain to you—in simple, plain English terms—how it handles each of these issues.

2

AUCTION AND
EBAY FRAUDS

Online auction fraud accounts for three-quarters of all complaints registered with the FBI's Internet Crime Complaint Center.

Some 35 million Americans have participated in an Internet auction at least once. Most are happy with their experiences—but a sizeable minority isn't. According to one survey, four in 10 buyers claim they've encountered problems with the auctions.

There are many types of online auction fraud—but the most common buyer complaints involve:

- receiving items that are different than those promised,

- items arriving in damaged condition,

- never receiving the items at all.

Sellers report problems such as late payment, non-payment, buyers changing their minds, checks bouncing and buyers using stolen credit cards.

In April 2003, the Federal Trade Commission targeted Georgia resident Morgan Engle as part of Op-

eration Bidder Beware, a law enforcement crack-down focusing on Internet auction fraud.

The Feds filed suit against Engle in U. S. District Court in Atlanta, charging that he advertised computers and musical instruments for sale on various Internet auction sites. As the bidding progressed, he sometimes circumvented the auction process by e-mailing consumers or telephoning them directly to offer a better price and discuss payment terms and delivery details.

But he rarely delivered the goods and rarely provided refunds, according to the FTC.

In October 2003, Engle settled the FTC charges by agreeing to a stipulated final judgment (which did *not* constitute an admission of guilt).

The settlement barred Engle from:

- selling goods or services via Internet auctions for life;
- making misrepresentations in the sale of goods or services; and
- from violating the FTC's Mail Order Rule.

It required that he post a $35,000 performance bond before engaging in telemarketing and required him to pay $5,820 for consumer redress.

The FTC also alleged that in a separate case—which had not yet been settled—Engle and several code-fendants combined auction fraud with serial identity theft to conceal their identities and divert the blame to the ID theft victim.

According to the Feds, Engle and company added the new wrinkle sometime in 2001. While he advertised and accepted payment for merchandise he never delivered, Engle set up bank accounts and post office boxes in other people's names—and had payments sent to those people.

Initially, law enforcement agents believed the identity theft victims were the ones who'd bilked the consumers. Only after several victims compared their stories did the pattern emerge.

According to the FTC, Engle's identity theft victims were people with whom he had feuded, people whose identity information he and an accomplice had taken from the records of a suburban Chicago hotel...and even from a dead man. A U.S. district court in Chicago seized Engle's assets to preserve them for restitution.

MECHANICS OF AUCTION FRAUDS

Crooks often establish a good member rating on eBay (or other sites) by ordering and paying for inexpensive items such as CDs or videos.

Once a good profile is established, they begin auctioning expensive equipment—that may not even exist—intent on defrauding the eventual winner.

And you don't have to win an online auction to lose out in an auction fraud.

One crook set up auctions on eBay using photographs of cars he didn't own and setting the reserve amounts higher than most people would expect to pay. (A reserve amount is the minimum payment a seller will accept for an eBay auction item; it's not usually made public—and known only to the Web site and seller.) He didn't want to sell the cars; he just wanted to make contact with potential victims.

Using the list of bidders, the crook contacted each independently of eBay and offered to sell him or her a similar car at a bargain price. He took deposits (usually in the $5,000 to $10,000 range) on the high-end cars...and disappeared.

If you're looking at an online auction site's rating system (such as eBay's star-based ratings) to make a decision about a seller, keep a few points in mind:

- a rating system is not designed to prevent specific acts of fraud; they are like movie reviews—subjective impressions of anecdotal experiences;

- make sure that a seller's latest transactions are recent; sometimes crooks hack into a dormant seller's account and hijack that seller's identity to fool customers who think they're dealing with a highly-rated seller;

- be wary of sending funds to sellers who accept only money orders or checks; there's no easy way to retrieve those funds if the sale goes bad.

And, if you're thinking of selling something through an online auction, proceed carefully, don't

select a winner too quickly—and get your money before you send your item.

Crooks are drawn to "low-feedback" (that is, new) sellers on eBay and other sites. They will try various ploys to make a great offer, convince you to send the thing you're selling...and never pay.

One important point, whether you're buying or selling: Law enforcement is not equipped to handle small- to midsize auction frauds. The FBI and the Secret Service usually won't get involved in an online fraud unless the dollar amount is near $100,000.

While eBay is a mechanism for many auction frauds, other companies are drawn into crooked deals, too.

Western Union has become a middleman in a lot of scams. Crooks involved in everything from advance-fee schemes to auction rip-offs use the company's cash transfer (commonly called "wire") services. These services appeal to crooks for two reasons:

1) they serve as an easy way to get money anywhere in the world. Sometimes it can be picked up with an answer to a security question and no ID;

2) they avoid the U.S. Postal Service, so the online scams don't break federal postal regulations.

The simple solution: Don't use Western Union's cash transfer service to send money to people you don't

know. (This isn't a knock on Western Union. In fact, the company has a separate service called Western Union Auction Pay that even *it* recommends for eBay purchases.)

Here's one example of why you shouldn't use Western Union wires for Internet auctions:

> A woman wanted to buy a speaker system on eBay. Instead of bidding, she could buy immediately at a set price. The only requirement was that she had to be "pre-approved."
>
> Since eBay doesn't pre-approve bidders, the seller suggested another way to make sure the buyer had the money. The seller suggested the buyer use Western Union's money transfer service. She would send money to her husband at a Western Union office in London (her husband didn't live in London...but the wire was supposed to be just an exercise). This would prove that she had the money; she would be safe because only her husband could pick it up.
>
> She wired $1,000. Less than an hour later, someone walked into the Western Union office with a fake ID and picked it up.

A PARTICULARLY NASTY BUNCH

Internet auction crooks can be particularly nasty. Since they rarely interact with their victims, they seldom develop the smooth talk and personal skills that traditional con artists work hard to refine. In fact, many Internet crooks—when confronted with

their crimes—have a hard time acknowledging any personal responsibility.

In April 2005, a federal judge in Maine sentenced 21-year-old Charles Stergios to more than six years in prison for running a series of scams that cheated some 320 people out of more than $420,000.

Stergios repeatedly wrote counterfeit checks to eBay sellers from whom he bought things like jewelry and electronics. He also took payments for items he advertised on the auction site but never shipped to the buyers. He was able to keep his scheme going because each individual fraud was relatively small; the most expensive transactions were valued at around $5,000.

> **Still, his aggressive behavior invited reprisal. His victims reported that he mocked them and sent insulting e-mails to those who complained about being cheated.**

Stergios had pleaded guilty in October 2004 to three counts of bank fraud, wire fraud and mail fraud. At that time, he told the court that he couldn't help himself and that he had become addicted to money the way others get hooked on drugs or alcohol.

"Money was my drug, my obsession," he said. He acknowledged defrauding more than 50 victims out of more than $200,000—but more victims came forward after the plea was entered.

The case had gone through some strange turns. In issuing the sentence, the judge rejected a plea bargain that had been reached between prosecutors and Stergios' lawyers. Also, at an earlier hearing, Stergios had thrown a pitcher of water across the courtroom at a prosecutor who called him a thief.

> The rejected deal would have sent Stergios to prison for just under five years. So, the pitcher of water cost the hotheaded felon about 15 months in prison.

U.S. District Judge George Singal explained that he was imposing the longer sentence because Stergios had "shown a complete lack of remorse in this case. In my view, you are likely to perpetrate when you come out of incarceration."

The judge noted that, when Stergios first pleaded guilty, he was ordered to pay back his victims. However, he continued to defraud other people and tried to hide assets to avoid paying anyone back.

A SCAM'S SHORT LIFE CYCLE

Here's a chronology of how one person was ripped off in an auction fraud.

On February 22, 2002, the victim visited UBID.com and placed a bid on a high-definition 42" Toshiba TV. The next day, he received an e-mail from the seller stating that the victim had won the auction and requesting a payment of $950 via Western Union wire.

When the victim hadn't wired the money within 48 hours, the seller sent another e-mail saying "I think that you don't want to make business with me. I must put the TV up for sale because I need money. E-mail me soon to know what to do."

The next day—February 26—the victim used Western Union's online service to wire the seller the $950 and sent the seller a confirmation e-mail.

Several days later, the victim checked the status of the wire on Western Union's Internet site. It showed that the money had been picked up in New York City. The victim sent an e-mail to the seller asking when the TV would be shipped. The seller replied that it would in a few days. Nothing ever arrived.

Two weeks later, the victim e-mailed the seller, asking for shipping information. There was no reply. The victim e-mailed the seller again several times. Then, on March 17, he sent a message via UBID's service, explaining that—to avoid legal trouble—the seller needed to respond immediately. There was no response.

The next day, the victim reported the fraud to UBID and Western Union. He also filed a complaint with the National Fraud Information Center. There was no specific reply from any of these.

The victim studied the seller's e-mail headers and was able to identify four IP addresses from which (or through which) the e-mails had come.

The first two addresses turned out to be from an Internet café in Romania. The third was a dynami-

cally-assigned address from America Online. The fourth address was most disturbing: It belonged to the Saudi Arabian United Nations mission. In New York City. Where the cash had been picked up.

AUCTION CROOKS MOVE FAST

In May 2003, police who'd been trailing Michael Dreksler for months found his body in the garage of his Colorado home—an apparent suicide.

Law enforcement agents from Arizona and Colorado had been investigating Dreksler and his wife Nancy, who'd allegedly been ripping people off in Internet frauds for several years. Specifically, the cops were assembling a case against the Drekslers that involved scams totaling about $110,000.

The Drekslers knew that the police were on their trail, so they started moving. A lot. The couple moved from Nevada to Arizona to Colorado in less than a year.

> **Police had trouble keeping up with fast-moving couple; in a common development, they ended up relying on former victims for updates.**

One former victim belonged to a group of adult Web site owners who'd been bilked by a couple who called themselves Mark and Nancy Shae. The Shaes also ran Internet pornography sites...and participated in forum discussions on design and busi-

ness topics. Then, suddenly, Nancy Shae said that her husband had died. The group sent her money (some $60,000, in all) and pitched in free labor to help her keep her sites running.

In fact, Nancy Shae was Nancy Dreksler. And her husband hadn't died...yet.

After the money arrived and the group members had helped her develop new site pages, Nancy "Shae" vanished.

The Drekslers began auctioning inexpensive DVDs using bogus eBay IDs. Soon, they switched to more expensive stereo components. The scams were simple: They'd take the money from "winning bidders" and never send the products.

Several months went by. And then, by luck, one of the ripped-off pornographers recognized some of the design work the group had done for Nancy one a Web site called AdultCanvas.com. He contacted the site, posing as someone interested in its owners' design services and who wanted to pay with cash sent by FedEx (a fairly common practice among Internet pornographers).

> The Drekslers took the bait and sent the former victim their new physical address—which is required for a FedEx delivery. They expected thousands of dollars to arrive in a day or two.

Instead, the victim immediately forwarded the address to the Arizona police, who had warrants for the Drekslers. The Arizona cops drove up to Colorado and coordinated with local law enforcement. They raided the Drekslers' rented house.

Once inside, they found Michael's body in his car (purchased by fraudulent means). Apparently, he'd asphyxiated himself. Nancy was gone. But the police and sheriff's deputies seized five computers from the home, along with various fake credit cards.

> The Drekslers' landlord told the investigators that, when Nancy rented the house, she'd told him she had a lucrative contract with eBay.

eBay has an internally developed application designed to detect early signs of fraud, called FADE (Fraud Automated Detection Engine). Also, the company said—when it acquired online payment service PayPal—that its auction site would be safer, since the two services could share insights on fraud.

That combination didn't seem to work in the Dreksler case.

FRAUDULENT ESCROW SITES

A common scam that crooks use when buying items in online auction is the fake escrow site.

Escrow services are used in Internet auctions to prevent fraud; they act as independent third parties—receiving buyers' money, assuring sellers that they can safely ship the goods and holding the payment until the buyers have received and inspected the merchandise. Once the consumer is satisfied with the purchase, the escrow service funds are turned over to the seller.

The crook will offer a premium price for an item and then tell the seller that the money has been sent to an escrow site. The escrow site then contacts the seller and says that the money has been placed in an account by the buyer. It will be released as soon as the buyer receives the item. The seller sends the item to the buyer...but never gets any money from the escrow site.

A short time later—maybe days, maybe weeks—the escrow site shuts down.

In many cases, the person running the escrow site and the person "purchasing" the item are the same.

Fake escrow sites can also work when the crook is selling something. People send money but never get the items they thought they purchased.

Some tips for sorting out fake escrow sites:

- look at the domain registration information at NetworkSolutions.com or other free resources;

> If the registration's physical location or corporate identity don't match the information on the site, beware; the escrow site might have been registered with a stolen identity.

- ask for a list of Internet merchants that use the escrow site; if the list is shorter than 10 companies, beware;

- check out the other companies that use the escrow site; start at the bottom of the list that the site offers—and compare each company's contact information with what's listed for them at NetworkSolutions.com;

- if any of the contact information for the escrow site and the companies is the same, beware;

- beware of escrow sites that use third-party e-mail services (such as AOL or Hotmail) for online correspondence.

In late 2003, the FTC brought charges against a group of defendants set up a fraudulent online escrow service.

In the FTC case, the crooks allegedly acted as either buyers or sellers of merchandise. Whether they "bought" or "sold," they insisted the deal be processed by their own—bogus—firm, premier-escrow.com. Consumers who were scammed had no reason to suspect that premier-escrow.com was crooked.

According to the FTC, when consumers sold merchandise (such as computers or cameras) premier-escrow.com assured the sellers that the money was in hand and the sellers should ship the merchandise. These sellers allegedly shipped their merchandise to the scammers and never heard from them or premier-escrow.com again.

The FTC alleged that when consumers bought merchandise—in one instance, an automobile—premier-escrow.com collected their money...but the purchasers never received the merchandise.

A U.S. district Court in Virginia ordered a halt to the scam, dismantled the premier-escrow.com Web site and froze the defendants' assets, pending trial.

CONSIDER WHAT YOU'RE BUYING

Be aware that some types of products—consumer electronics, jewelry, designer clothes and accessories—attract Internet auction crooks (as buyers or sellers) more than others.

In March 2004, a North Carolina Internet retailer was arrested after she defrauded victims out of thousands of dollars selling fake designer clothing on eBay and other Web sites.

Tammy Nesmith claimed that she sold urban brands like Baby Phat, Parasuco and Sergio Valente on the Internet; but patches and stitching on the clothes were telltale signs of fakes rather than the "100 percent legit" clothes Nesmith promised in her ads.

Nesmith was arrested at her day job after two victims traded information on her operations and whereabouts on a Web site devoted to tracking down scam artists. The victims contacted the police who promptly made the arrest.

Nesmith faced a lot of legal problems. In addition to the charges in North Carolina, she had an outstanding warrant for grand theft in California. She'd operated under several aliases in many locations—and law enforcement agents hadn't been able to connect all of the pieces until her arrest.

In North Carolina, she faced five counts of obtaining property by false pretense. Local police said they had been contacted by numerous victims in the area-several of whom had lost as much as $5,000 to Nesmith.

Nesmith said she used to sell clothes and handbags and other items out of a store in Garner, N.C. She claimed that everything she sold through eBay from the physical store was legitimate and delivered in a timely manner.

According to Nesmith, her problems started when she decided to leave the store; after that, she started working with third parties who may have shipped fake clothes.

TIPS FOR PROTECTING YOURSELF

What can you do to protect yourself from online auction scams?

- Keep your transactions to reputable auction sites—and don't do business with people who contact you independently from the site.

- Whenever you're purchasing something on the Internet, use your credit card. Be wary of sellers who won't take a credit card or use a payment service that allows you to use a credit card.

- If you pay cash (or check), use escrow companies that are recommended by reputable auction sites. Be wary of sellers or buyers who insist on using an escrow site you've never heard of.

- Understand that some third-party payment systems (specifically, Western Union) are not escrow services and make no assurance that your payment will be applied to your purchase.

- Do some research on the sellers or buyers with whom you're dealing. If you receive an e-mail from someone who's selling something, you're not going to automatically check the headers to see what IP address it came from. But you should.

- Don't count on seller ratings as reliable indicators of a seller's (or buyer's) trust-worthiness. They're not designed to do that.

3

NIGERIAN ADVANCE FEE SCAMS

In October 2000, an American businessman killed himself in a London hotel room after losing his life savings to a Nigerian Advance Fee scam. Jerry Stratton took drugs and slashed his wrists after he was tricked into believing he could make over $10 million by investing $75,000 in what police called a "classic 419 fraud."

The police found a note written by the 47-year-old Stratton—a plumbing contractor from Florida—which read in part: "If anything happens to me, look for three people. They are Nigerians."

Stratton had gotten caught up in a scam operated by West African crooks operating out of the U.K. Potential victims were offered huge profits if they put up money to help bribe officials at overseas banks to release cash held on account. The con men then disappeared with the victims' money—leaving them with worthless contracts or promissory notes.

Several notes for $50,000 were found in Stratton's room. He had been persuaded by the crooks to expect vast profits from the $10 million deal. But the deal was plagued with problems and delays.

Through the summer and fall of 2000, Stratton tried—unsuccessfully—to raise another $65,000 from family and friends to keep the deal going. Finally, in October, he flew to England in a last-ditch attempt to salvage the deal. But he had no luck even locating his supposed contacts.

Relatives became worried when he told them he "had nothing to come home for." And they were right. As it turned out, he didn't.

WHY *NIGERIAN* SCAMS?

Nigeria has become a hotbed of financial frauds. There are many scams that start—or are popularized—in the African country; the most notorious is the Nigerian Advance Fee Scam, also known as a 419 fraud (after the section of the Nigerian criminal code that addresses fraud schemes).

A crude scam originating from an African country might seem unlikely to fool Americans. But the Financial Crimes Division of the U.S. Secret Service receives approximately 100 telephone calls from victims and potential victims and 300 to 500 pieces of related correspondence *each day*.

Nigerian Advance Fee Scams frequently use the following setup tactics:

- a target receives an e-mail, letter or fax from an alleged "official" representing a foreign government or company;

- the fake official creates a sense of urgency—government turmoil, criminal threats or other problems;

- the fake official offers to transfer millions of dollars into the target's personal bank account—and asks the target to hold the money for a short period, keeping a portion of the money as a fee;

- the target receives numerous documents with official looking stamps, seals or logos testifying to the authenticity of the proposal;

- the target may be asked to provide blank company letterhead forms, banking account information, telephone/fax numbers—so that the fake official can draft banking documents for moving the money.

The money to be transferred will usually range from about $4 million to as much as $60 million. The target is usually offered a commission of between 10 and 30 percent for assisting in the transfer.

At some point (and the most effective crooks wait a while before doing this), the target is asked to pay an advance fee of some sort. This fee may be called a *transfer tax*, *performance bond*, *bribe* or *refund*. In many scams, the first fee is relatively small—a "test" of whether the target will respond with action.

If the target pays the first fee, the fake official will come up with complications that require more money. The complications continue until the target quits, runs out of money—or both.

The perpetrators of advance fee frauds can be creative with the details. There's no limit to the premises that these scams involve. Common premises fall into a few basic categories:

1) transfer of funds from over-invoiced contracts,

2) disbursement of money from wills,

3) real estate transactions,

4) conversion of hard currency and

5) sale of crude oil at below-market prices.

In some variations on this scheme, a Nigerian residing in the U.S., U.K. or other country will claim to be an agent or "clearing house official" for the Central Bank of Nigeria. And some manage to use offices in legitimate government buildings or embassies to add an appearance of legitimacy to their scams (whether the government was knowingly involved remains an unresolved question).

COMMON TRAITS

The details of particular Advance Fee scams may vary; but some basic characteristics remain the same in every one. Most Nigerian Advance Fee scam letters or e-mails share these traits:

- They are addressed to "president" or "CEO," rather than a specific name.

- They are marked "urgent" and "confidential."

- They state that the recipient has been recommended because of his or her hon-

esty and business acumen...or that this reputation has been verified by a board or committee.

- The dollar amounts to be transferred are written out in text form—i.e., $32,460,000 appears as "THIRTY-TWO MILLION, FOUR HUNDRED AND SIXTY THOUSAND UNITED STATES DOLLARS."

Also, the sender will usually claim to be one of the following:

- a senior civil servant from an industry trade group or a government ministry (the Nigerian National Petroleum Corp. [NNPC], the Ministry of Trade and Industry, Ministry of Finance, Nigeria Export Promotion Council [NEPC], etc.);

- the spouse, relative, aide or confidante of a deposed leader;

- a member of the "Nigerian royal family;"

- a businessman or lawyer with an impressive title such as "Chief," "Barrister" or "Doctor;"

- an auditor or accountant with strong ties to Nigerian officials; or

- a religious figure such as a deacon, brother or pastor.

Here is an actual example of a Nigerian Advance Fee scam letter:

Lagos, Nigeria.

Attention: The President/CEO

Dear Sir,

Confidential Business Proposal

Having consulted with my colleagues and based on the information gathered from the Nigerian Chambers Of Commerce And Industry, I have the privilege to request for your assistance to transfer the sum of $47,500,000.00 (forty seven million, five hundred thousand United States dollars) into your accounts. The above sum resulted from an over-invoiced contract, executed commissioned and paid for about five years (5) ago by a foreign contractor. This action was however intentional and since then the fund has been in a suspense account at The Central Bank Of Nigeria Apex Bank.

We are now ready to transfer the fund overseas and that is where you come in. It is important to inform you that as civil servants, we are forbidden to operate a foreign account; that is why we require your assistance. The total sum will be shared as follows: 70% for us, 25% for you and 5% for local and international expenses incident to the transfer.

The transfer is risk free on both sides. I am an accountant with the Nigerian National Petroleum Corporation (NNPC). If you find this proposal acceptable, we shall require the following documents:

(a) your banker's name, telephone, account and fax numbers.

(b) your private telephone and fax numbers—for confidentiality and easy communication.

(c) your letter-headed paper stamped and signed.

Alternatively we will furnish you with the text of what to type into your letter-headed paper, along with a breakdown explaining, comprehensively what we require of you. The business will take us thirty (30) working days to accomplish.

Please reply urgently.

Best regards,

HOW THE SCAM PROCEEDS

What happens when a target responds to one of these stilted pitches?

Soon, documents arrive from the Central Bank of Nigeria, the Nigerian National Petroleum Corporation or other official-seeming entities. The documents carry government letterhead, stamps and seals. The package may include several of the following forms:

- Fund Management Agreement

- Fund Remittance Voucher

- Fund Release Order Form

- Affidavit of Fund Ownership

- Sworn Affidavit of Truth/Claim, Transfer Authority

- Approval/Transfer of Payment Warrant

- Confirmation of Banking Particulars

- Foreign Exchange Control Approval Order

The forms are all bogus. At best, they are based on real government forms (though not necessarily from Nigeria); at worst, they are completely fabricated by the crooks. And they'll sometimes support these documents by inventing bogus government committees or fake publications that echo their stories.

In the midst of all of this bogus paperwork, the crooks ask the target to supply signed and stamped blank company letterhead and blank invoices. Also, banking information—such as account numbers, addresses, telephone and fax numbers.

> **The victim may believe that his real banking information is a fair exchange for all of the paperwork he's received. But that paperwork is all fake.**

Then the trouble starts. The initial contact person tells the target that the deal has hit a snag. Some person or organization in Nigeria is holding up the transfer. The victim can help solve the problem by providing some cash to "take care of" a greedy attorney or government official.

In one scheme, government lawyers wanted two percent of the money—$195,000—in advance, for their services. The victim refused to advance that much money; so, the contact person offered to negotiate. He called back, jubilant that he'd talked the lawyers down to $100,000. Still, the victim hesitated.

Later, the contact person called again and offered to sell his house to provide $25,000—if the victim could manage the rest. The victim agreed.

After more delays, the contact person called again and said that the Nigerian bank president expected a gratuity to authorize the transfer.

> In these scams, the victim constantly faces the prospect of either losing his initial payments or paying even more fees, hoping for the big payoff. In this way, tens or hundreds of thousands of dollars may be swindled.

The crooks swear that each fee is the last; but oversights, errors, complications or temporary difficulties crop up—necessitating additional payments and delays. The collection of these advance fees is the real objective of the scam.

Once people get hooked, they become blind to the prospect that the whole process is a scam. They become invested—psychologically, as well as financially—in the deal. Denial prevents some people from *ever* seeing that they've been swindled.

HOW THE CROOKS FIND VICTIMS

Nigeria scam crooks get the names of potential victims from a variety of sources—including trade journals, professional directories, newspapers and commercial libraries. They don't target individuals; they send out mailings in bulk.

However, the letters are designed to make a victim believe he has been *singled out* from the masses to share in multimillion dollar windfall profits...for doing nothing.

> The goal of the crook is to delude the target into thinking that he is being drawn into a lucrative—albeit questionable—arrangement. The target must believe in the potential success of the deal in order to look past its shadiness.

In fact, the victim often becomes the primary supporter of the scheme and willingly contributes a large amount of money when the deal is threatened. The con-within-the-con is that the venture will be threatened unless the target provides a steady flow of money for various bribes and fees.

As long as the victim pays that fee, another is sure to come up. The crooks will keep pressing the victim until the victim can't or won't pay any more. Then, the crooks vanish.

STATISTICS ON THE SCAMS

Victims of Nigerian Advance Fee scams lose about $3,000 on average, according to the FBI. But the money is only part of the problem. Several victims have been killed or gone missing while chasing the scam—or the scammers.

In some cases, if a victim doesn't stop paying, the crooks may invite the victim to come to Nigeria—

or one of the neighboring countries—for a face-to-face meeting. The victims are sometimes told that a visa will not be necessary to enter the country.

The Nigerian con artists then bribe airport officials to pass the victim through Immigration and Customs.

> Because it's a serious offense in Nigeria to enter without a valid visa, the victim's illegal entry may be used by the crooks as leverage to coerce the victim into releasing more money. Violence and threats of physical harm may also be used.

SOME VARIATIONS

In February 2005, the U.S. Department of Homeland Security issued a warning about two separate e-mail variations on the Nigerian scam.

- In the first variation, an e-mail writer claimed to be a volunteer working with U.S. forces in Iraq. The e-mail asks for help in returning money belonging to a recently-killed U.S. soldier to his family. And the e-mail included a hypertext link to a page from the actual DHS Web site that allegedly verified the mailer's identity.

- In the second scam, the e-mail writer claimed to be a federal agent from the DHS's Immigration and Customs En-

forcement bureau. It asked recipients for help tracking down money looted from the Iraqi Central Bank by Saddam Hussein's sons. The e-mail also linked to the DHS Web site and asked for confirmation of the recipient's personal information.

Both e-mails seemed to be targeted at the families of people serving in the U.S. military. Each offered potential victims a percentage of monies transferred or recovered in exchange for various types of assistance—including the use of personal banking information.

DHS spokespeople called both e-mail campaigns bogus and urged people to ignore and delete them.

WHAT NIGERIA IS DOING

The Nigerian government periodically makes statements that it is cracking down on the scams. But many experts doubt its sincerity; 419 scams are big business in Nigeria (by some accounts, they constitute the third-largest industry in that country).

In October 1999, the real Central Bank of Nigeria released a "press statement" that tried to clear up some of the confusion. The Bank noted:

> ..The Central Bank and indeed, the Federal Government of Nigeria cannot and should not be held responsible for bogus and shady deals transacted with criminal intentions. As a responsible corporate body, the Central Bank of Nigeria is once again warning all recipients of fraudulent letters

on bogus deals, that there are no contract payments trapped in the bank's vaults. They are once again put on notice that all documents appertaining to the payment, claims, or transfers purportedly issued by the bank, its senior executives or the Government of the Federal Republic of Nigeria for the various purposes described above are all forgeries, bogus and fraudulent.

Still, there have been some reports of high-level officials of the Nigerian government and the Central Bank of Nigeria personally participating in the scams—though the government insists these are only clever imposters.

IF *YOU* GET A 419 LETTER

- Don't respond to the solicitation.

- Send copies to local and federal law enforcement agencies.

- File a complaint with the Nigerian Embassy or High Commission in your area. (It used to be possible to e-mail complaints and 419 materials in to the Central Bank of Nigeria and to the Nigeria Police, but those e-mail addresses have not worked for some time.)

- If the contact from the crooks was via e-mail, write the e-mail provider at its "abuse" address (abuse@yahoo.com, abuse@onebox.com, etc.) and include the scam message with its headers. Complain about the scam message and ask that the crooks' account be shut down.

- File complaints with watchdog groups like Spamcop.com. These groups can get the crooks' e-mail accounts shut off by whatever ISPs they are using.

Include the message's full header information. This is necessary for tracking the message's origin. Full headers aren't usually shown by the default settings of most e-mail software. If you don't know how to display full headers, check the instructions in your e-mail program or Web site. (Many Web page-based e-mail hosts include a "full header" option link near the top of the message.)

The U.S. Secret Service has instructed Americans who've lost money Nigerian scams to forward appropriate written documentation to:

U.S. Secret Service
Financial Crimes Division
950 H Street, NW,
Washington, DC 20001.
T (202) 406-5850
F (202) 406-5031
e-mail: 419.fcd@usss.treas.gov

Some law enforcement agents suspicious of the Nigerian government's intentions. There are enough scams that involve the government that the cause seems to be more than just clever imposters.

In May 2001, a Michigan-based engineering firm filed a $100 million federal lawsuit against the government of Nigeria, the state-owned petroleum company and bank and several high government officials for racketeering and fraud. The suit alleged that the Nigerian entities refused to make good on a $25 million contract and that he was cheated out of $500,000 while trying to recover what he was owed. More than 20 Nigerian citizens were also listed as defendants.

Will Tolliver first heard from the Nigerians in 1994. Representatives of the Nigerian state-run oil company contacted the American Concrete Pipe Association about help with an oil pipeline problem. Several long sections of concrete pipe were settling badly and starting to break. The pipe association suggested Tolliver, a highly regarded specialist with numerous patents in his field.

> The Nigerian officials proposed paying Tolliver's company—Tradco, Inc.—10 percent of whatever he would save over the original engineering proposal. The repair project was completed and the savings were pegged at $250 million.

Tolliver never received his $25 million, however, and resigned himself to getting nothing.

Then, in July 1999—four years after the repair work had been completed—Tolliver received a letter from officials who claimed to represent the government.

They told him that he would get his money, though he would have to pay a few "routine" fees first.

Tolliver, who was ill at the time, had an associate travel to various locations in Africa and Europe to negotiate with Nigerians. Each step of the way, the associate paid tens of thousands of dollars for pledges that the money soon would be coming.

At one point, the contract was "renegotiated" and Tolliver was told that he would receive $100 million for his time and efforts. The fees continued.

Finally, after paying about $500,000, Tolliver decided he'd had enough and cut off the spending. "You look at it and realize, 'I am throwing good money after bad money'," he said.

That's exactly what the Nigerian 419 scam expects victims to keep doing.

4

INVESTMENT, BUSINESS AND BANKING SCAMS

There are as many investment and business frauds as there are stars in the nighttime sky over the Great Plains. But most of these scams are variations on a few basic premises. So, the best way to avoid getting ripped off in a business or banking swindle is to understand how the few basic types work...and keep a wary eye out for "business opportunities" that present themselves.

We've considered the Nigerian 419 scheme (probably the most common "business opportunity" in the 2000s) in detail already. In this chapter, we'll consider more domestic frauds.

> Internet commerce has been a boom for crooks who use various banking or financial instruments—including checks, demand drafts, electronic payments, etc.—to rip off victims.

In one case, the Colorado Springs Police Department warned of a banking scam that had defrauded

numerous local residents. In each case, the local resident had communicated with someone over the Internet and received some type of financial instrument. The local victim was asked to deposit the funds into his or her bank account and then transfer some or all of it out by wire, usually to someone outside the country.

Variations of this scam include the following:

- A person places an ad on the Internet for the sale of a large-ticket item—such as a car, motorcycle or boat. A crook, usually from outside the country, responds that he wants to buy the item. The victim receives a check or money order in an amount above the negotiated price and is asked to refund the balance to the buyer via a wire transfer.

- A crook advertises online or in local media to hire "secret shoppers" who will be paid to test the efficiency and convenience of stores and consumer service companies. The first "assignment" is to test a money wiring service. The crook sends a counterfeit cashier's check for $1,000 and asks the "shopper" to cash it, wire back $800 to test the service and keep the rest as a fee. There is no second "assignment."

- A person receives a letter from a foreign lottery company stating that he has won a huge sum of money in a lottery. Later, the person is sent a smaller cashier's check and is instructed to de-

posit the check and wire transfer some of the money back to the company in order to pay "taxes and fees" in order to receive the rest of the jackpot.

In each case, the victim later finds out that the checks, cashier's check or money order is fake. And that victim owes his bank whatever money he wired to the crook.

The Colorado Springs police advised residents not to wire transfer money outside the country unless they knew the intended recipients. And, if someone received a cashier's check or money order (including a *U.S. Postal Service* money order) from an Internet transaction, he shouldn't remove the money until the instrument had cleared the bank.

MECHANICS OF CHECK FRAUD

Check fraud is the most common type of banking scam or swindle. In many of these scams, the crook will ask the victim to cash a bogus check and wire the proceeds back to the crook. In effect, the crook uses the victim as a check-cashing service...and the victim gets left owing his or her bank the amount of the fraudulent deposit.

How can this happen?

> The key point: When a person opens a checking or savings account with a bank, he or she agrees to be personally responsible for the full value of any deposits he or she makes into the account.

The rest is simply a matter of misplaced trust.

> **Step One**: The target deposits a check at his or her bank. Immediately, the target's bank electronically verifies the check. A teller or bank officer looks up the check maker's account on a computer; if the account exists and has enough money to pay the check, the target's account will be credited with the amount of the check.

> **Step Two**: If the check being deposited is a cashier's check or if the target is a customer in good standing, the target's account may be credited with the funds immediately. This means that the target's bank puts its own money into the target's account, pending receipt a few days later of the funds from the deposited check.

> **Step Three**: If the check that the target deposited is denied by the bank that issued it, there is no money to replace the money that the target's bank credited to the target's account. The target's bank will take the money back out of the target's account. If the target has removed some or all of this money in the meantime, he or she (not the crook who made the check) is responsible for replacing it.

Most banks will grant immediate credit for paychecks, Cashier's Checks and other checks which—in their experience—are usually paid without any problems. Other checks (including checks from individuals, checks drawn on banks in other states or checks with amounts over $5,000) are often subject to holds.

When a deposited check has a hold placed on it, the funds will not be available in the target's account until the check has actually been paid by the bank that issued it—or, in banking jargon, until the check "clears."

Some banks clear checks more quickly than others. This has been especially true since the Federal Reserve began its Check21 program—allowing banks to replace paper checks with electronic copies.

Check21 encourages banks to use "electronic clearing." They electronically verify the check at the time it's deposited and send an electronic debit to the bank on which the check was drawn. This debit "holds" the money to cover the check at its originating bank. Then one of two things happens: the physical check travels through one or more check clearinghouses (operated by or under agreement with the Federal Reserve); or an electronic copy of the check is made and the paper version is destroyed.

The originating bank can electronically acknowledge receipt of the target's bank's debit, debit the maker's account and forward the funds back through the system to the target's bank. In most cases, the target's bank will then immediately credit the funds to the target's account.

> In the meantime, the physical check may be moving through several clearinghouses between the target's bank and the originating bank. The process can take anywhere from a few days to a few weeks.

When the physical check arrives at the originating bank, it is inspected by bank employees and declared valid or invalid.

If the check is a cashier's check, traveler's check, money order or similar item, this inspection happens fairly quickly; if the check is a corporate or personal check, the inspection can take weeks—and may not happen at all, until the check is returned to its maker with a monthly statement.

If a check is declared invalid, the maker's bank will send an electronic debit for the amount of the check plus handling fees back to the target's bank. The target's bank must pay this debit from its funds—and settle the matter separately with the person.

Check fraud isn't prosecuted often or aggressively. Most law enforcement agencies consider it a rather low-priority "white collar crime." Cases often result in probation or light jail sentences for crooks.

PHONY "DEMAND DRAFTS"

Demand drafts, also known as "remotely created checks," have become an attractive tool for crooks. Most people assume that checks must be signed by an authorized account holder. That's ordinarily true—but not in the case of demand drafts.

Demand drafts look just like checks, but indicate "signature not required" or a similar message in the authorized signature area. And, generally, banks

cash them just like signed checks. These instruments were designed to accommodate legitimate telemarketers who receive authorization from consumers to take money out of their checking accounts. But the potential for abuse is high. Not only do they not require a signature, but they require no action by the checking account holder.

> No one knows exactly how many demand drafts are written each year, because the checks are processed just like regular, signed checks. And no one knows how commonly they are used for fraud.

In April 2005, the National Association of Attorneys General called on the Federal Reserve to ban demand drafts, citing increased fraud. In a letter to the Fed Chairman, the group wrote:

> *The fact that a stranger can pull money out of a person's bank account using only the numbers at the bottom of his or her check is not commonly understood. Complaints about unauthorized bank debits are believed to be grossly underreported, perhaps because of the lack of public awareness of this type of bank account vulnerability.*

The letter went on to point out that one community bank had surveyed demand drafts and found a startling *73 percent* to be fraudulent.

For several months in early 2004, a Canadian firm using the Internet Web site PharmacyCards.com created demand drafts and withdrew $139 from

checking accounts all over the United States. In all, about $3 million was successfully debited from consumer accounts.

The Federal Trade Commission sued the site, alleging that it had tried to remove money from checking accounts belonging to some 90,000 consumers and had transferred most of what it could take to a private bank account in Cyprus. The FTC claimed that all of this had taken place without the consumers' knowledge or approval.

Indeed, many victims said that they'd never even heard of PharmacyCards.com until they saw the debits on their bank statements. When they went to the firm's Web site, they found what appeared to be a drug discount program with marketing ties to major retailers like Kmart and Wal-Mart.

> But none of those firms had authorized the use of their names or logos on the PharmacyCards site. In fact, nothing about the site and drug discount plan were legitimate; they were just pretexts that allowed the crooks to turn a list of consumer bank account numbers into millions of dollars in cash.

Starting in early 2004, consumers began to complain to their banks and federal regulators about unauthorized withdrawals from their checking accounts. The checks had been fabricated using consumer account information—and, in the space normally meant for their signatures, the phrase "signature not required" was stamped.

In its lawsuit, the FTC alleged that two companies were behind PharmacyCards.com. One, HelmCrest Limited, was based in Nicosia, Cyprus. The other, 3rd Union Card Services, Inc., was based in Delaware. When the firm's banking transactions required a U.S. presence, 3rd Union Card Services' address was used; but all funds were wired to HelmCrest's account in Cyprus.

> The federal judge in Nevada granted the FTC a injunction that shut down PharmacyCards.com from making any more demand drafts. The site shut down permanently a few weeks later.

There's nothing a consumer can do to prevent a demand draft. And, unlike electronic withdrawals or ATM card debits, the account activity is not governed by federal law. Each state has its own rules covering demand drafts. So, the FTC advises consumers to check their bank statements carefully for unexplained charges, and to inform their banks immediately if anything suspicious appears.

WHO REGULATES THESE THINGS?

The regulatory structure that oversees bank transactions—including checks, demand drafts and electronic transfers—in the United States is rather complex. In most cases, the federal government (through either the Federal Reserve or the Treasury Department) is in charge; though, in a few cases, state banking officials may be.

In most states, consumers who complain about a bad demand draft within a reasonable amount of time are entitled to a refund from their bank.

Federal Reserve rules give a bank only 24 hours after receiving the check from the institution that cashed it to make a fraud determination. That makes the crook's job easier, since banks rushing their reviews are less likely to detect fraudulent demand drafts—at least until a consumer complains, which is usually after the 24-hour period.

Under a proposed policy making the rounds in late 2005, the Fed would set a new nationwide standard that puts the liability on the bank that cashes the demand draft in the first place. This would place the burden on that bank to check its authenticity. In addition, the paying bank would have 60 days to return a bad check (which is similar to regulations for electronic payments).

While some law enforcement groups insist that demand drafts should be banned completely, banking industry insiders note that few payment systems ever completely disappear—even if they become unpopular.

And bankers have a dispassionate view about crooks. They usually argue that thieves and con artists—a group that bankers call "bad actors"—can game any system.

> **Banks can be philosophical about check fraud because they are usually not held responsible for its direct costs.**

IS INTERNET BANKING SAFE?

The popular view is that expanded use of the Internet by consumers is the chief cause of growing scams. But, in January 2004, James Van Dyke—a research analyst for Javelin Strategy—concluded that using the Internet for banking and paying bills actually *reduces* the threat of identity theft and bank fraud.

Contrary to popular opinion, Van Dyke found that using the Internet for bill paying and banking can reduce risks and save consumers up to 60 hours of personal time and $1,100 in the cost of paper checks and postage.

His report, *Online Banking and Bill Paying: New Protection from Identity Theft*, concluded that using the Internet could help protect consumers and businesses from two of the most common kinds of identity theft: fraudulent opening of new accounts and unauthorized use of existing accounts.

The report concluded:

> *That's because criminals get their information from traditional sources, such as low-tech, off-line services. If consumers did more of their transactions online, they would actually reduce their risk of identity theft.*

The report concluded that consumers who view accounts and pay bills online are nearly four times more likely to monitor activity *closely* than those who wait for paper bills and monthly statements.

> **That consumer watchfulness may be more effective in protecting against fraud and identity theft than the millions of dollars businesses spend on fraud-monitoring technology.**

PHONY BUSINESS FINANCE

Crooks love to offer bogus banking and finance services to small businesses and people starting businesses. New businesses often combine enthusiasm and capital—two great prerequisites for getting ripped off.

One bogus business start-up offer read:

> *FREE CASH GRANTS, NEVER REPAY!*
>
> *You Can Get The Money You Need...*
>
> *To Start Your Home Business...*
>
> *To Consolidate Your Debt...*
>
> *To Go To college...*
>
> *Almost ANY Worthwhile Reason...*
>
> *Why?*
>
> *Foundations all over the United States GIVE away Millions of Dollars of CASH GRANTS*

every year. They must give this MONEY away, in order to maintain their tax free status.

Who Can Apply? ANYONE can apply for a Grant from 18 years old and up! We Can Help! We will show you HOW & WHERE to get Grants. This MONEY has to be given away, WHY not to YOU? Grants from $500.00 to $50,000.00 are possible! GRANTS don't have to be paid back! Grants can be ideal for people who are or were bankrupt or just have bad credit.

The Good News!

DON'T pay $79.00 to $129.00 for this information and list. We Will Show You How To Apply For Your Grants, Where To Apply, And Exactly What To Say. We Help You Do It All For Just $32.95.

If You Pay With Credit Card, All Information Will Be Sent To Your E-mail Address Within 24 to 48 Hours!

What you get for $32.95 is a list of foundations, which you could get for free from a local public library. Of course, the foundations don't "give money away." They make grants, usually to nonprofit organizations, who write detailed plans that demonstrate how the funds will be used to advance whatever causes a particular foundation is interested in.

SCAMMING "PARTNERS"

An experienced con man whose real name was Joseph Dixon Acheson, Jr. left a trail if victims throughout the Midwest and West during a six-year run of banking and small-business scams during the late 1990s.

In those years, Acheson rarely used his own name—claiming, instead, to be Walter Thomas Nemecek (who was a real person Acheson had known some years earlier).

Acheson had some experience as a carpet installer, cleaner and salesman. So, when he moved into a new town, he could usually find legitimate work with a carpet company. The carpet industry is often built on complicated webs of relationships among contractors, subcontractors and independent contractors. A con man can find many places to hide in all the complexity.

Acheson was crafty. He convinced most of his employers to sign some kind of "business agreement" with him. In most cases, he proposed the agreement as a way to clarify his independent contractor status and avoid employment law hassles; in fact, he knew that a written business agreement (even a badly-drawn or incoherent one) makes a criminal fraud conviction almost impossible.

In fact, a badly-drawn business agreement can be a great cover for a crook. It can make all sorts of frauds and thefts legally defensible. Depending on how the agreement is worded, it can make the parties "partners" for the sake of some deals. So, prosecutors will usually end up advising victims to try to resolve their "disagreements" in civil court.

Acheson's biggest scam took place between 1998 and 2000, while he was working for a carpet company in Nevada. Following his standard practice, he convinced the owners to sign an independent contractor agreement to "protect" all parties. He worked legitimately for the company for more than a year. Then, after he'd earned the owners' trust, he vanished with more than $100,000 of their equipment and carpet stock.

When the owners went to the police, they were told that the contractor agreement made the situation impossible to prosecute. So, they were left with suing the crook in civil court. They won several judgments—but these judgments were against Nemecek, who was living unassumingly as a janitor in suburban New York.

The real Nemecek was able to prove that he wasn't the crook; and the carpet company owners from Nevada had to publicize their problems among victims' rights groups. These efforts seemed futile at first; but, in late 2002, they paid off.

Acheson had moved on to the St. Louis, Missouri area and was working several smaller versions of his carpet installer scam. One of his victims in that area read about his Nevada rip-off, recognized some similarities and contacted the local police.

Because Acheson was still actively perpetrating his frauds in Missouri, the police were able to arrest him. Initially, he refused to tell the police who he was. But, once his fingerprints had been taken, he realized his lies were about to collapse—so, he admitted to being Joseph Dixon Acheson.

The Missouri police discovered that Acheson had a long criminal record, including an outstanding arrest warrant in Florida for parole violations.

Prior to *those* problems, Acheson had been in and out of jail on dozens of charges—fraud, forgery, drugs, burglary, assault—dating back to the 1980s.

IS YOUR PARTNER A CROOK?

When you enter a contract with someone, you assume a number of financial and business risks. Unless the agreement clearly states that you do not accept those risks, law enforcement agencies will treat all sorts of bad actions as "business disputes" best left to civil courts or arbitration.

Here are some tips for avoiding these problems:

- Don't sign any sort of "business agreement" if you can avoid it.

- If you are inclined to sign a "business agreement" drafted by another person, make sure you have an attorney review the document first. Instruct your attorney to look for any language that might allow the other person to treat your property as if it's jointly owned.

- Perform a due diligence check on any person with whom you're thinking about investing money or signing any sort of "business agreement." This due diligence check doesn't have to match FBI standards—a simple credit check

or even an online search may do. Let the person know you'll do this before taking any formal action.

You're looking to confirm basic information: Is the person who he says he is; do the person's Social Security number, previous addresses and other information match up; has the person had any major civil judgments or trouble with law?

- Do the check—even if you've already invested money. It may still provide information that will help you reduce any losses that might come from bad business. Reliable information will be useful if you're victimized...and it may help other victims.

Also, check out some of the many online fraud victims' Web sites, chat rooms and databases. The best-known of these include:

- www.crime-research.org
- www.crimes-of-persuasion.com
- www.fraudaid.com
- www.naag.org
- www.scampatrol.org
- www.scamvictimsunited.com
- www.straightshooter.net

Several of these sites (and other good ones are start-ing up all the time) have databases and "black-lists" that include names and information on people who have scammed others. Since most are private-sector groups, they can be more aggressive about naming names than government agencies.

PHISHING BASED ON BANKING

In the midst of a booming Internet banking and communications marketplace, some fairly crude phishing scams masquerade as bankers. Consider the following e-mail:

Date: Mon, 12 Sep 2005 18:19:30 +0800

To: {name withheld}

Subject: Unauthorized Account Access Bank of Oklahoma

From: "OnlineBanking"

Dear Bank of Oklahoma customer. Please read this message and follow it's instructions.

Unauthorized Account Access

We recently reviewed your account, and we suspect an unauthorized ATM based transaction on your account. Therefore as a preventive measure we have temporary limited your access to sensitive Bank of Oklahoma features. To ensure that your account is not compromised please login to Bank of Okla-homa Internet Banking and Investing by click-ing this link , verify your identify and your online accounts will be reactivated by our system. To get started, please click the link below.

Important information from Bank of Oklahoma. This e-mail contains information directly related to your account with us, other services to witch you have subscribed, and/or any application you may have submitted. Bank of Oklahoma and its service providers are committed to protecting your privacy and ask you to send sensitive account information through e-mail.

In fact, the link in the e-mail took the reader to site that looked legitimate...but merely recorded the personal and account information that gullible victims entered there.

And, once the crooks had that information, they could start making demand drafts immediately....

GETTING YOUR MONEY BACK

What can you do to try to get some of your money back, if you've been scammed?

> **The short answer is: Don't expect much and prepare to fight hard in court.**

You can pursue criminal charges through the proper law enforcement agency (usually your local police and district or state attorney). If this goes well and the crook is convicted, you can ask for restitution as part of the sentencing.

Depending on the state and county, the crook may have to remain on probation until the money is repaid.

Also, you can sue the person in civil court. A civil judgment will allow you to have the crook's personal property seized, his bank account levied and his paychecks garnisheed. This is a good option if the thief is employed and has assets. Unfortunately, most of the people who scam do not have stable employment or assets.

> If you get a judgment against someone, you can hand it over to a judgment recovery specialist. This is a debt collector who goes after judgment debtors. This person will have a financial motivation to find your money; the fee you'll pay is usually 30 to 50 percent of any money collected.

Half of something is better than nothing.

The safest policy: Avoid business scams in the first place.

MORTGAGE
FRAUDS

Through the late 1990s and 2000s, real estate values all around the United States increased markedly. The number of mortgages—original loans and refinance packages, assembled through banks, brokers and other companies—increased, too.

Crooks and scam artists were sure to follow all of this business activity.

According to FBI Criminal Investigation Division head Chris Swecker:

> ...*The FBI investigates mortgage fraud in two distinct areas:* Fraud for Housing *and* Fraud for Profit. *Fraud for Profit is sometimes referred to as "Industry Insider Fraud" and the motive is to remove equity, falsely inflate the value of the property or issue loans based on fictitious properties. Based upon existing investigations and mortgage fraud reporting, 80 percent of all reported fraud losses involve collaboration or collusion by industry insiders. ... The FBI defines industry insiders as appraisers, accountants, attorneys, real estate brokers, mortgage underwriters and proces-*

*sors, settlement/title company employees, mortgage
brokers, loan originators and other professionals
engaged in the mortgage industry.*

Mortgage lending is the least regulated part of the
financial services sector. The Feds watch the details
of the banking industry's deposits and cash trans-
actions closely; but they've traditionally left the
details of how loans are made to state regulators.

According the FBI, mortgage fraud in the United
States increased 25 percent from 2004 to 2005—
and was up almost 400 percent in three years.

> **These numbers may understate the problem. Ac-
> cording to the FBI, mortgage fraud is hard to detect
> because four out of five cases involve dealings be-
> tween industry insiders. And the legitimate profits
> made during a real estate boom can hide all kinds of
> frauds and illegal fees.**

While the FBI described mortgage-related fraud as
a national problem, it said the levels of illegal activ-
ity are worse in some locations than in others. The
Feds identified 10 "hot spots" for mortgage fraud—
big cities in Georgia, South Carolina, Florida, Michi-
gan, Illinois, Missouri, California, Nevada, Utah and
Colorado.

The Feds point out that the growing role of third-
party mortgage brokers contributes to the levels of
fraud and abuse in the real estate market.

But what exactly *is* mortgage fraud? Law enforcement agencies and legitimate lenders generally focus on the following types of fraud:

1) Predatory lending: Lenders—sometimes banks, sometimes individual "investors"—make loans with illegally high interest rates or fees to uninformed or unqualified borrowers.

2) Equity stripping: A lender or investor loads an otherwise fair loan with unfair fees and terms.

3) Property flipping: Property is purchased, appraised and financed at an unrealistically high price and is either sold or goes into default. Flipping is often intended to defraud the lender— as much or more than the unsuspecting buyer. Sometimes kickbacks to buyers, investors, brokers, appraisers or title company employees also occur.

4) Mortgage-related identity theft: A stolen identity is used on a loan application without the true person's knowledge.

PREDATORY LENDING

In general terms, predatory loans can be described as financing which the borrower does not understand and cannot repay. These loans are a bad outgrowth of the legitimate subprime residential mortgage market.

Subprime loans are generally more expensive than standard loans; they are intended for borrowers who pose a greater risk to lenders, typically because of the lack of credit or a poor credit rating.

Affordable housing advocates said that the most important lending issue of the 2000s is no longer denial of credit, but the terms of credit.

Legitimate subprime loans become predatory when they include exorbitantly high interest rates (often not fully or fairly disclosed to borrowers), excessive fees or transaction costs, inappropriate penalties and other abusive features.

In March 2001, the Federal Trade Commission charged Associates First Capital Corporation and Associates Corporation of North America—known jointly as The Associates—of engaging in "systematic and widespread abusive lending practices, commonly known as 'predatory lending.'"

The FTC charged that the company had violated federal law by convincing unsophisticated home owners to refinance existing debts into home loans with high interest rates, costs and fees. It also claimed that The Associates hid essential information from consumers, misrepresented loan terms and forced optional fees on borrowers.

The company obtained its customers through a variety of means, including direct mail offers that in some cases included "live checks." If a victim cashed

the check, she was automatically accpeting a loan from The Associates. Once in the system, victims were pressured to take out new loans or refinance their existing debts.

According to the FTC:

- The Associates' promotional materials stressed—in many cases, falsely—that debt consolidation loans would lower borrowers' monthly payments and save them money.

- The Associates trained employees to tell consumers there'd be "no out-of-pocket fees" or "no up front out-of-pocket costs," when its loans had high points and closing costs.

- Borrowers were told that they'd "save money" by consolidating existing debt into a new loan with The Associates. But loan fees and closing costs typically *added* to the borrower's loan principal.

- The Associates' loan marketing materials often did not reveal that, with some loans, consumers would still owe the entire principal amount in a "balloon payment" at the end of the term.

- The Associates induced borrowers "to purchase, unknowingly, optional credit insurance products"—a practice known as *packing*.

The FTC also charged that The Associates employed abusive and unfair tactics in collecting on their loans, including:

- disclosing consumer debt information to third parties without consent;

- calling borrowers at work after being advised that such calls were inconvenient or not permitted;

- making repeated and continuous telephone calls to consumers with intent to annoy, abuse or harass.

The case proceeded in a Georgia federal court for about 18 months. Then, in September 2002, the FTC announced a settlement. The Associates would pay $215 million and promised to reform its consumer lending practices.

HOW THE LAWS WORK

While federal laws don't (usually) regulate the terms of mortgage loans, they do regulate disclosure—what lenders tell borrowers and how they tell it.

Specifically, the Home Equity Protection Act of 1994 (Section 32 of Regulation Z, part of the Truth in Lending Act) requires extensive disclosures if:

- for a first mortgage, the annual percentage rate (APR) exceeds by more than eight percentage points the rates on Treasury securities;

- for a second mortgage, the APR exceeds by more than 10 percentage points the rates in Treasury securities; or

- the total fees and points payable by the consumer at or before closing exceed the larger of $510 or eight percent of

the total loan amount. (The $510 figure is for 2005. This amount is adjusted annually by the Federal Reserve Board.)

Credit insurance premiums for insurance written in connection with the loan are counted as fees.

These rules primarily affect refinancing and mortgages that meet the definition of a high-rate or high-fee loan. (They don't cover standard mortgages, mortgages on commercial real estate, construction loans or home equity lines of credit.)

If a loan you're offered meets those bad standards, you must receive several disclosures at least three business days before the loan is finalized:

1) The lender must give you a written notice stating that the loan need not be completed, even though you've signed the loan application and received the required disclosures. You have three business days to decide whether to accept the loan agreement.

2) The notice must warn you that, because the lender will have a mortgage on your home, you could lose it and any money put into it if you fail to make payments.

3) The lender must disclose the APR, the regular payment amount, and the loan amount (where the amount borrowed includes credit insurance premiums, that fact must be stated). For variable

rate loans, the lender must disclose that the rate and monthly payment may increase and state the amount of the maximum monthly payment.

The following features are banned from high-rate, high-fee (also called Section 32) loans:

- Balloon payments—where the regular payments do not fully pay off the principal balance and a lump sum payment of more than twice the amount of the regular payments is required.

- Negative amortization, which involves smaller monthly payments that do not fully pay off the loan and that cause an increase in your total principal debt.

- Default interest rates higher than pre-default rates.

- A repayment schedule that consolidates more than two periodic payments that are to be paid in advance from the proceeds of the loan.

Lenders also may not:

- make loans based on the collateral value of your property without regard to your ability to repay the loan;

- refinance a Section 32 loan into another Section 32 loan within the first 12 months of origination, unless the new loan is "in the borrower's best interest;"

- wrongfully document a closed-end, high-cost loan as an open-end loan. For

example, a high-cost mortgage may not be structured as a home equity line of credit if there is no reasonable expectation that repeat transactions will occur.

Finally, there are two important points to keep in mind about Section 32:

1) the law requires disclosure for onerous loan terms—but it does not *ban* such loans;

2) it allows loans with awful terms and no disclosure—for example a loan 7.99 percentage points above the rates on Treasury securities of comparable maturity and requiring 7.99 points.

HOW TO AVOID BAD LOANS

The report *Separate and Unequal: Predatory Lending in America* by the Association of Community Organizations for Reform Now (ACORN)—a nonprofit national community organization for low- and moderate-income families—says minorities and low-income home owners are often steered toward more expensive subprime loans, even when they could qualify for less expensive standard financing.

ACORN's report included the following suggestions for avoiding predatory loans:

• Before applying for a mortgage, get mortgage counseling. Local housing departments, community groups, faith-based organizations and others

(not affiliated with lenders) either have such programs or know about independent counseling centers.

- If you are already in the middle of the loan process, talk to the counselor to evaluate any loan offers you receive.

- Ignore high-pressure tactics. Before you sign anything, take the time to have an expert such as a housing counselor or attorney look over the purchase agreement, offer and related documents.

- Before closing your loan, get a copy of your loan papers with the final loan terms and conditions so you have time to examine them. Tell the escrow company, lender or any others who will be present at the signing that you will need time to read over all the documents and that you do not wish to be rushed. If anything is dramatically different at closing, don't sign it.

- Be wary of high points (each point is one percent of the total loan amount) and fees. Loans typically cost 1 to 3 percent of the loan amount for points and fees to the lender. If you are being charged more, ask why.

- Don't accept a lender's statement that you have bad credit without reviewing your credit report yourself for mistakes and inaccuracies and having an independent person evaluate your credit.

Some other tips for avoiding predatory loans:

- Avoid borrowing more than the value of your home. Owing more than your house is worth can prevent you from selling your house or refinancing at a better rate at a later date.

- Avoid single-premium credit life or credit disability insurance designed to pay your mortgage if you die or are injured. The insurance is of little value and is often a tool of predatory lenders.

- Avoid prepayment penalties. Many subprime loans come with penalties you must pay if you refinance your loan or sell your home within the first few years of your mortgage. If you believe you might sell or refinance within the prepayment term, get a loan without a prepayment penalty.

- Avoid balloon payments. Balloon mortgages have the payments structured so that after making all your monthly payments for several years, you still have to make one big "balloon payment" that can be as much as your original loan amount. If, when the balloon is due, you can't make the payment or refinance, you can lose your home.

Also, the person or company promoting a predatory loan may not be a sleazy lender or loan broker. In some cases, the bad deals come from unexpectedly directions. For example, some crooked contractors offer to do work on a house and even provide cash to owners—but never mention that the deal is powered by a predatory loan.

EQUITY STRIPPING

Equity stripping is a common method of mortgage fraud—and it comes in various forms. Today's common equity stripping schemes may involve the use of corporate shell companies, corporate identity theft and the use or threat of bankruptcy/foreclosure to dupe homeowners and investors.

But the main way that crooks steal money in equity stripping scams is by adding lots of bogus costs and fees into standard loan packages.

This is the main way that equity-stripping differs from predatory lending. The actual loans in these scams may not be illegal or abusive—they may even be good; but the fees bundled in along with them are crooked.

The main law that bans equity stripping is the Real Estate Settlement Procedures Act (RESPA).

Courts have held that RESPA does not apply to every overcharge for a real estate settlement service; and it isn't a "broad price-control provision." It only prohibits overcharges when a "portion" or "percentage" of the overcharge is kicked back to or "split" with a third party. Compensating a third party for services actually performed, without giving the third party a "portion, split or percentage" of the overcharge, does not violate the law.

In other words, a legal claim under RESPA requires some provable degree of collusion or kickback between service providers—such as loan brokers, lenders or title companies. This is a difficult thing to prove; any old markup won't do.

A clear case of equity-stripping scams came to light in March 2002, when the FTC and six state attorneys general announced a settlement with Irvine, California-based First Alliance Mortgage Company.

First Alliance was in bankruptcy; but, in its heyday a few years earlier, it had been a major lender in prime and subprime mortgage markets.

As part of the settlement, about $60 million from the assets of First Alliance would be distributed to 18,000 homeowners around the country who'd been charged excessive fees on loans they obtained from First Alliance between 1992 and 2000.

> The settlement stated that First Alliance had fraudulently misled borrowers into believing their loans came with minimal fees when, in fact, the fees went as high as 24 percent of the total mortgage principal in some cases.

The Feds alleged that First Alliance had marketed its loans using sophisticated techniques designed to mislead borrowers. Consumers who visited First Alliance offices were typically subjected to a lengthy sales presentation known inside the company as the

"Track." The presentations glossed over the existence of substantial "points"—each equivalent to one percent of the amount being borrowed—and grossly understated fees on mortgages taken out by the unsuspecting borrowers.

The firm targeted "vulnerable" homeowners (often senior citizens with no mortgage debt) and persuaded them to take out loans that they may not have actually needed, said federal lawyers.

PROPERTY FLIPPING

Flipping is usually orchestrated by a seller with ties in the real estate and/or mortgage business. In some cases, the seller either is or controls the real estate agent and mortgage broker involved in the sale.

In the classic model, someone who owns a mortgage broker and/or title company will buy an inexpensive property, mark it up excessively and resell it to a buyer who's either "in" on the scheme or an unsuspecting dupe. Either way, the buyer will usually end up defaulting on the inflated loans soon after he or she takes possession.

> Crooks usually try to work with buyers who are dupes—naïve but greedy people looking to make quick money in real estate. Even when buyers are "in" on the scheme, they are often well-meaning friends or relatives who think there's little risk in what they're doing.

The flipped properties are usually not primary residences; they're rental houses, duplexes or small apartment buildings intended as investments.

The best environment for flipping is a bigger city, with older neighborhoods that are being rehabilitated or "gentrified." In these neighborhoods, it's not unusual to see a beautifully renovated 50-year-old house standing next to another 50-year-old house that's an un-remodeled mess.

An important point: Flipping is not necessarily illegal. Legitimate real estate investors buy rundown houses, fix them up and resell them in a few months. The process only become illegal when the investor knows that the property has been appraised, mortgaged and/or sold above its market value.

Identity theft in its many forms is a growing problem and is manifested in many ways, including mortgage documents. The mortgage industry has indicated that personal, corporate and professional identity theft in the mortgage industry is on the rise. Computer technology advances and the use of online sources have also assisted the criminal in committing mortgage fraud.

A clear case of illegal flipping came to a close in August 2005, when attorney Chalana McFarland was sentenced to 30 years in federal prison. A jury convicted her of heading a vast flipping operation that scammed $20 million from inflated mortgages on more than 100 homes in the Atlanta area.

Specifically, the charges McFarland faced included wire fraud, bank fraud, money laundering, and conspiracy to commit the offenses of wire, mail and bank fraud, money laundering, identity theft, use of false Social Security numbers and making false statements to HUD in its Section 8 Housing Assistance Program. She was also charged with making false statements and perjury.

> McFarland worked with at least 20 coconspirators employed as real estate agents, mortgage brokers and loan processors. The ring used fake identities, fraudulent documents, shell companies and "straw" borrowers to buy houses—then quickly resold them at artificially inflated prices.

McFarland owned and operated The McFarland Law Firm in Stone Mountain, Georgia. Her practice focused on real estate transactions; she acted as an agent for title insurance companies and was the closing attorney for various lenders. This put her in an excellent position to run real estate scams.

She included a number of friends and associates in her operation, including: two paralegals in her firm; a mortgage broker; several independent real estate appraisers; two licensed real estate agents; and a former student at Florida A&M University who had access to computer files with students' names, Social Security numbers and other information.

McFarland and her crew would buy inexpensive residential properties in various suburbs around

Atlanta. At the same time, they would set up so-called "straw borrowers" pre-qualified through HUD programs or standard banks to buy houses in the same areas—for considerably more.

As soon as McFarland's crew got control of an inexpensive property, it would work with crooked appraisers to establish a higher value and then quickly sell the property to a straw borrower for the inflated price. Then, the crew would pay off whatever small loan it had on the property and keep the difference.

In some deals, McFarland's accomplices would also serve as "straw sellers." They would lie about owning a house, enter an agreement to sell it to a straw borrower for an inflated price, wait for the loans to fund—and then buy the house for a lower price and transfer it through escrow.

> **Since McFarland was working as the lender's agent in escrow, she could assemble paperwork and appraisals, disperse the cash for the straw seller to buy the house...and sign off on the transfer later.**

McFarland was good at setting up paperwork. In most of the deals, she would create elaborate fake employment histories and bank account information for her straw borrowers. The "employers" were usually empty shell corporations and the bank info, altered accounts belonging to other people.

Often, the "seller" and "buyer" in these transactions were both nonexistent. But the houses were real.

According to the Feds:

> *McFarland caused HUD-1 Settlement Statements to be signed certifying that she received and disbursed loan proceeds as reflected on the HUD-1s when she closed mortgage loans for various lenders on the properties for which she wrote title insurance, with the actual McFarland receipts and disbursements not as reflected on the Settlement Statements.*

Those disbursements included five-figure payments to crooked appraisers, mortgage brokers and real estate agents.

In many of these deals, the McFarland's crew could net $100,000 from a single house. The straw borrower would often default on the mortgage within a few months of the inflated sale...and either the lending bank or HUD would end up taking over a property saddled with loans far greater than its actual value.

WHEN THE TIDE TURNS

The booming real estate markets of the 1990s and 2000s have provided cover to many shady real estate swindlers. Some real estate professionals and economists worry that when the hot markets finally start to cool, hundreds of crooked mortgage deals will emerge all over the United States.

CHARITY SCAMS

Charities and not-for-profit organizations (like churches and religious organizations) have a special place in American society. In many circles, the phrase "not-for-profit" carries so much moral authority that the actual purpose of the organization claiming the status never needs be explained.

This is a ripe environment for scammers.

In April 2005, the San Rafael, California-based Urban Age Institute received an e-mail from a donor offering an unexpected $1,000 donation. The donor asked for instructions on how to wire his donation into the not-for-profit group's operating account. Not thinking anything unusual about the out-of-left-field request, the group's accountants sent the donor the relevant account numbers.

Within days, $10,000 worth of checks had been written against the Institute's accounts and cashed by a woman in Georgia.

The Georgia woman—apparently an innocent dupe in the scam—believed that she was cashing checks

for a "boyfriend" she had "met" through an Internet dating service. She cashed the checks through her bank and then used Western Union to wire at least half of the money to the boyfriend. In Nigeria. He claimed that he was an American working there "on assignment."

The Nigerian crook's greed tipped off the Urban Age Institute. He sent the nonprofit a check (using other stolen account information) for $3,000 and asked it to wire $2,000 back to him. This proposal seemed strange to the Institute's management; they had one of their executives investigate the check before cashing it.

All of the crook's fraudulent checks—the ones drawn on the Institute's checking account and the one presented as a donation to the Institute—were printed and mailed by a company called Qchex.com.

> Qchex.com prints and mails checks remotely for businesses and people. The service is most useful for online transactions; but the also company markets itself as an inexpensive and easy alternative to any standard use of checks.

Some law enforcement agencies have noted that Qchex.com's security functions are minimal; at one point, users only had to provide a working e-mail address as identification. Spokespeople for the company admit that some fraud has occurred through the site—but no more than at other Internet payment services, such as eBay's PayPal.

An Urban Age Institute executive tried to register at Qchex.com, in order to find out more about the $3,000 "donation" check that the Institute had received. She discovered that the Institute's bank account information and at least one e-mail address had already been used to set up a remote checking account. In an ironic turn, the Web site prompted the executive to "contact the existing account holder to obtain authorization for using the above account."

Moving quickly, the Institute was able to close the breached checking account before money was taken out to cover the checks that the Georgia woman had deposited.

> She was the person most directly hurt by the scam. Her bank held her responsible for nearly $5,000 that she had wired to her bogus beau.

The checks she had deposited—which would have been drawn against the Institute's account—had the account holder name "Edward William" and a southern California address. These bogus bits of information agreed with what the cyber beau had told her about himself.

And the strange name wouldn't have stopped the checks from being processed; banks that accept remotely printed checks (and not all banks do) usually don't attempt to verify that the account number matches the name on the account.

COURTING DISASTERS

The modern media culture is fascinated with disasters—both natural and man-made. Not-for-profit organizations and charities know this...and often tie their fund-raising and promotional campaigns to disasters.

Crooks know this...and often pretend to be charities raising money the wake of hard times. The main difference between the charities and the crooks is that the crooks keep all of the money they collect.

A wave of crooks swept through the U.S in the weeks and months after the 9/11 attacks. Among the many scams they perpetrated:

- One group sent out e-mails asking for financial support for computer experts who were supposedly attempting to track Osama bin Laden. The e-mail gave a bank account number—to which donations could be deposited—and the name of an individual who turned out to be located in Estonia.

- A voice mail message asked for help in raising $1 million for victims of the attacks. When people called the number back, they reached the answering machine for a decidedly *for-profit* telemarketing company.

- Fraudulent telemarketers, some pretending to be from Publishers Clearing House and Readers' Digest, promised "donations" to national recovery

and rescue efforts if consumers pur-
chased magazines or other products
with sweepstakes entries.

THE ASIAN TSUNAMI

In January 2005, immediately after the Asian tsu-
nami that devastated the coastal areas around the
southern India Ocean, a mass e-mail posing as a
plea for aid to help the victims made the rounds of
the Internet. But the charitable mission of the e-
mail was a fraud; the e-mail was actually a vehicle
for spreading a computer virus.

The worm appeared with the subject line: "Tsu-
nami donation! Please help!" and invited recipients
to open an attached file named tsunami.exe. The
attached program file forwarded the virus to other
Internet users whose addresses were stored in the
infected computer.

It also initiated a denial-of-service attack against a
German computer services Web site.

The English computer security consulting firm
Sophos first identified the worm and figured out its
bad purpose. The technology of the fraud was not
new—but the pretext of charitable work was slea-
zier than usual.

According to Sophos consultant Graham Cluley,
"Duping innocent users into believing that they
may be helping the tsunami disaster aid efforts shows
hackers stooping to a new low."

Other worms followed. One played to religious biases (though not particularly American religious biases), using the message that the tsunami was God's...or Allah's...revenge on "people who did bad on earth." The effect was the same; if a user clicked on the attached program, his or her computer became a zombie used for denial-of-service attacks.

Also, the Asian tsunami became a useful pretext for variations on familiar scams—including Nigerian 419 frauds. One version of this was an e-mail appeal from a (fictional) Thai businessman suffering from a fatal disease who'd lost his family in the tsunami. He needed help collecting millions of dollars from a European security firm and distributing it to Asian charities on the scene of the disaster.

The e-mail made the familiar proposal that, if the victim used his or her bank accounts to transfer the funds, he or she could keep a six-figure fee. "I need a God-fearing and trustworthy person that will be able to travel to Europe, to collect this deposit from the security company," the e-mail read.

The usual parade of delays and "minor fees" followed....

HURRICANE KATRINA

The focal point of charity scams during the 2000s, though, was immediate aftermath of Hurricane Katrina.

In the summer and fall of 2005, Internet Web sites purporting to be charities related to the hurricane appeared faster than law enforcement agencies could look at them—and many were fraudulent.

According to FBI cybercrime division head Louis Reigel, there were roughly 2,300 Katrina-related sites up and running within a week of the hurricane reaching land. New sites were popping up "faster than we can pound them down," Reigel said at the time. And he noted that the number of sites and the money being donated had already exceeded what the FBI had seen following the Asian tsunami six months earlier.

During the weeks after Katrina, the FBI received more than 250 complaints about aggressive or otherwise suspicious hurricane-related charities. From these complaints—and its own work—the FBI had identified about 800 Web sites as likely bogus; about 60 percent of those had some connection to people or companies outside of the United States.

Reigel said that the FBI was working with the American Red Cross, whose Web site was the one most often imitated by crooks. Also, the U.S. Justice Department was establishing a Hurricane Katrina Fraud Task Force that would focus on phony charities, identity theft, insurance scams and government benefit fraud.

Reigel repeated familiar advice, cautioning people not to respond to online solicitations. He also

warned that such e-mails could contain worms and computer viruses.

The FBI's advice was slightly generic—but worth repeating, anyway:

- Be cautious about any solicitation that mentions a specific disaster.

- Give to charities you know and trust.

- If someone claims to be collecting money that will go to charities, ask which ones and check with them directly to make sure it's true.

- Confirm that charities are properly registered by contacting their state charities regulators, which are listed in the state government pages of telephone books.

Other tips for charitable giving include:

- Be suspicious of anyone wanting on-the-spot donations or refusing to provide written, verifiable information about their organization.

- Don't assume a charity is legitimate based on its name. Many scam artists will use a name that sounds similar to the name of a well-established charity.

- Don't make cash donations. Use a credit card or check so you'll have a record of the payment.

Information about charities is available from the Better Business Bureau's Wise Giving Alliance. The Alliance can be contacted by telephone at 1.703.276.0100 or online at www.give.org. Deceptive mailings can be reported to the Postal Inspection Service by calling 800-372-8347 or visiting www.usps.gov/postalinspectors/fraud.

EXPLOITING AID PROGRAMS

In September 2005, three Louisville, Kentucky women were arrested on felony fraud charges. They were accused of trying to cheat the American Red Cross chapter in a southeastern Indiana town out of hundreds of dollars in Hurricane Katrina relief.

Red Cross officials said they believed the case was part of a pattern of deceit in Clark County, Indiana (a suburb of Louisville), that included at least seven other individuals and families.

According to a local police report, the three women had claimed they were from Louisiana and asked for clothes and money. The said they'd lost all forms of ID in the hurricane. Red Cross workers gave them clothes and debit cards designed to help hurricane refugees buy food and temporary shelter.

Local Red Cross chapters usually take digital photos of applicants without identification before they hand out debit cards. And they try to verify the applicants' claimed addresses. But the director of the Clark County chapter said it didn't have access

to a national database of disaster victims maintained by the American Red Cross—and that the chapter's policy was to "err on the side of compassion."

This explains why the crooks had come to suburbs. The Red Cross chapter in downtown Louisville was connected to the national database.

The value of a Red Cross debit card is usually linked to the size of a family applying for help; it ranges from about $300 to $1,500. Acceptable purchases include food and clothing and—in some cases— toys for children or meals at a restaurant.

Officials in Clark County became suspicious of the Louisville women after receiving tips that some card users were nearby residents with few or no links to areas damaged by Katrina. The Kentucky crooks didn't realize that the Red Cross could track—in real time—how the cards were being used.

When the Red Cross officials investigated the cards given to the Louisville women, they saw that the cards had been used at stores which were "not typical" destinations for disaster victims. Specifically:

- one debit card had been used to buy $1,065 worth of items at Best Buy,

- another card was used to make $177 in purchases at Victoria's Secret, and

- a third card was used for $233 in meals over a four-day period at Ernesto's Mexi-

can Grill, Hooters and other restaurants in southeastern Indiana.

A spokeswoman at the American Red Cross headquarters said there could be an increase in fraud because of the sheer magnitude of the disaster. She said the problem was taken "very, very seriously."

In the wake of the criminal charges, the Clark County Red Cross took a few common-sense measures to prevent further abuse. With the assistance of the local police department, it would enter names of all applicants into a national crime database run by the FBI. And it would share names and other information with the Louisville chapter.

NAMES SOUND LIKE CHARITIES

Popular response to bogus charities can have a positive effect. In Katrina's wake, a popular Internet columnist for the *Washington Post* newspaper called attention to the Web site katrinahelp.com. He pointed out that the site was generally suspicious and included a "donation" button that directed users to a rather anonymous PayPal account.

> **Another red flag was that the site initially misspelled the word *hurricane*.**

After the columnist's story generated some outrage—and some contact from the FBI—the site's Florida-based owner (who used the childish handle "DemonMoon") quickly announced that the site was

under new management and removed the donation button. He also included some legitimate contact information for the Red Cross and other groups.

However, a short time later, the site only mentioned that its name was for sale.

As one Internet surfer noted:

> *Interesting that DemonMoon cannot write one, let alone two sentences, without misspelling key words. Don't think English is his native language. When he says "many {donations} go to help," he should have said that "ALL donations go to help."*

Another concerned surfer contacted DemonMoon about the site. That surfer reported about the experience—and offered some insights on the crook:

> *{DemonMoon} is a punk..., who replied with childish insults, swearing and idle threats of violence. I replied in kind and said I wouldn't leave him alone until his site was gone. I also e-mailed FEMA and Google about his scam. ...Some people may not agree with this method, but I have no problem with an Internet Posse. People like this are scum and have no place in any part of our society.*

Of course, katrinahelp.com wasn't the Internet's only shady "charity" site. Others included: neworleanscharities.com, donate-katrina.com, christiandonations.org, parishdonations.com, clergydonations.com, katrinafamilies.com and katrina-donations.com.

And one online poster said that he'd received his first e-mail solicitation for donations before the eye of Hurricane Katrina had made land.

Various ISPs were diligent about removing shady sites as quickly as their shadiness could be established. Through early September 2005, there was a lot of this removing going on.

THE EBAY/CHARITY ANGLE

In the weeks after Katrina hit the Gulf Coast, a number of eBay auctions appeared for selling Katrina-related Internet domain names. In each auction, the seller claimed that a portion of the final auction price will be donated to Katrina relief efforts. One such auction, which promised "3 PREMIUM HURRICANE KATRINA DOMAINS OR TSUNAMI .COMS" claimed it would donate half of the proceeds to the American Red Cross. The starting bid was $15,000.

Other scammers are more subtle. In the days after Hurricane Katrina struck, a crafty auction was posted on eBay. Its title "Sponsor 2 Hurricane Katrina Volunteers." Its description:

> *Organizations like the American Red Cross receive countless monetary donations every time a natural disaster strikes. These organizations require manpower, people to answer phones, rescue/recovery, case workers, in the home office and field offices. You are bidding to sponsor a couple who*

> *are volunteering to assist in the relief efforts. Auction will cover our living expenses while we volunteer.*

The seller—who set up the auction—was listed in the eBay system as living in Gainesville, Florida. So, what "living expenses" would he or she need covered to help out?

After some sharp-eye bidders raised questions about the details of the description, the Seller revised the description to state that "living expenses" would include offsetting personal expenses related to planning a local fund-raiser.

The changing definitions made the deal seem suspect; but eBay was not inclined to remove it from the site—as it does with most shady auctions—since it could have been a honest effort to do good.

That uncertainty is why charities will always be an attractive cover (or *front*) for swindlers and crooks. Non-profits get their moral authority from their good intentions. But, when it comes to the mechancis of donating money to people or groups you don't know well, it's hard to tell good intent from bad.

7

RUSSIAN BRIDES
AND SWEETHEART
SCAMS

Singles looking for romance often turn to Internet-based personal ads. So do criminals looking for easy targets.

With the rise of the Internet and the fall of the Soviet Union, a growing number of western men are turning to marriage agencies or introduction services to find Russian wives.

> Men who seek submissive women often gravitate to these agencies because Russian women are perceived—in a collision of stereotypes—as having "Asian sensibilities and European features."

Many of these agencies are crooked. And many of the men who seek Russian brides (40 percent, by some estimates) get in contact with a scammer at some stage of their search. Often, men discover that they've been corresponding with a scammer after they've developed strong feelings towards a "woman" they think they love.

It's a potent recipe for fraud. According to the U.S. State Department:

> *The United States Embassy in Moscow is receiving increasing numbers of complaints from American citizens who have been lured into online relationships via false Internet profiles. Often, these are men pretending to be women who make contact with Americans—usually men—over the Internet through dating Web sites or chat rooms. The fictitious person then seeks to create a virtual relationship through the exchange of photos and e-mails. At some point s/he begins to ask for money, frequently asking that it be transferred through wire services.*

In June 2004, a California man was sentenced to five years in federal prison for cheating men out of more than $1 million in a Russian bride scam.

The sentence was imposed from a plea bargain in which Robert McCoy admitted defrauding more than 350 men and agreed to pay back his victims $737,521. Investigators had evidence of even more crimes; but prosecutors focused on the strongest ones.

According to federal prosecutors, McCoy would locate victims through personal ads he placed or answered on Internet Web sites—including well-known ones like America Online and Match.com. He'd write e-mails posing as a Russian woman seeking marriage and sent pictures of a pretty model. Eventually, a visit would be arranged—but the victim would be told that a Russian dating service needed cash to pay for a visa and plane tickets.

> The money would be wired to accomplices McCoy
> had in Russia. The accomplices would split the pro-
> ceeds with McCoy and wire his share back to him in
> southern California.

On the day the victim was expecting the woman to arrive, McCoy would write as an official from the (bogus) dating service and say there was a problem: A "new regulation" required the woman to carry $1,500 cash to enter the United States. The service would lend her $500, but the victim needed to wire an additional $1,000.

Many of the victims wired the extra thousand. Then, they'd hear nothing.

The FBI's Cyber Crime Squad launched the criminal investigation in January 2002, after an individual reported he had been defrauded over the Internet. The victim told the FBI that he'd wired thousands of dollars to an agency which offered to expedite the travel of a Russian woman with whom he'd developed a relationship online.

Far from a mastermind, McCoy struck those who saw him as pathetic—a drug-addled felon who wore gang tattoos and had earlier convictions on assault, kidnapping and weapons charges. During the court proceedings, McCoy seemed barely able to speak. His lawyer blamed the crimes on McCoy's drug addiction (primary to methamphetamine) and said McCoy would use his prison time to get off drugs.

About the same time McCoy was being sentenced, Anna Grountovaia—the mother of his two-year-old daughter—was sentenced to three years probation after having served 11 months in jail. Grountovaia, a Russian national who'd "met" McCoy online before moving into his home, said she posed as a prospective bride in telephone calls with some of the victims. Her lawyer argued that Grountovaia had met McCoy after his scams were already under way and only played a minor role—filling in occasionally when McCoy needed a woman with a Russian accent. Still, she faced deportation back to Russia because of her guilty plea.

McCoy's elaborate scam shared many of the standard characteristics of bogus bride schemes. These characteristics include:

- Crooks usually misinform the American victims about travel expenses and/ or they inflate the cost of the expenses that do exist.

- Crooks lure the victims with e-mails, pictures, phone calls, fake visas and even e-mails from fake travel agencies.

- Typically, after the victim has advanced money to help the bride emigrate, something interferes. The bride may be "hospitalized for an injury" or claim a family member has health problems.

- Sometimes the bride will contact the victim, claiming to be stuck at a foreign airport and not allowed to depart until she can show she has a certain amount of money ($1,500 is a common

amount) to cover their expenses while in the U.S.

Again, their purpose is not to immigrate to the U.S., but to get as much money as possible from the victim. In this manner, the bride schemes are like the Nigerian 419 schemes—the victim is manipulated into believing that early "investments" justify later...and continued...investments.

WHY SO MANY *RUSSIAN* BRIDES?

Russia is an incubator for scams and confidence schemes. Its people are relatively well-educated; but the country suffers from low wages and high unemployment. It offers crooks an environment in which they can work, including uneven law enforcement and barriers to outsiders including a language many find impenetrable, strict visa rules and vast geographical spaces.

At the same time, Russian women have real reasons to look elsewhere for mates. They are treated surprisingly poorly—in both official and unofficial capacities. Many internalize the fatalism of the country's corrupt communist history and its patriarchal culture traditions. And they face tough statistical prospects.

As a result, there are hundreds of agencies on the Internet that provide "introduction services" or match-making for women in the former Soviet Union. And many are crooked.

How can someone tell a crooked match-making site from a legitimate one? This is a difficult question to answer—but a legitimate site should:

- screen the personal and criminal backgrounds of the women it features;

- have offices in either the U.S. or western Europe as well as Russia;

- accept major credit cards (without using third parties to process charges);

- offer support services and video clips either for free or at a nominal price.

Most agencies offer their services for free to the women featured on their sites and make money from fees they charge the men who want to find women. As a result, some legitimate agencies will have thousands of women applying for their services each year; and it can be hard even for an honest agency to vet each applicant completely.

So, even a legitimate agency can end up posting some bogus or scheming women on its site. In some cases, prostitutes will register with marriage agencies and attend the socials to pick up johns. (And, frankly, some agencies operate prostitution rings as a part of their business.)

Even when it doesn't involve prostitution, the process can be dehumanizing. Most agencies post photographs of the women and quick descriptions that can sound like ads for livestock; some agencies allow interested men to fill "shopping carts" of women they find interesting.

And these are the *legitimate* firms.

Agencies usually package so-called "love tours" for lonely men, including airline tickets, hotel accommodations and travel around Moscow or St. Petersburg. The agency schedules various social events, where the men can meet Russian women in person, talk with them (usually through interpreters) and try to get to know them. Some men go to socials to meet women with whom they've been corresponding; others go to meet a woman first and then begin correspondence.

> This "getting to know" each other can be difficult because there are often a few dozen Western men and as many as a thousand Russian women at the socials. Still, the meetings are important. At least one meeting is necessary to satisfy U.S. immigration requirements for fiancée visas.

And the chaotic process of matching American men with Russian women does yield some real results. The U.S. Department of Homeland Security's Immigration and Customs Enforcement bureau (ICE) estimates that 2,000 to 5,000 "mail order" marriages (a term the U.S. government still uses) between Americans and Russians occur each year.

THE FEDS CAN'T DO MUCH

The U.S. Embassy in Moscow does not have the authorization to initiate criminal investigations of Russian bride (or any other) scams. Nor can it verify the identity of specific Russian women. Most U.S. embassies (wherever they're located) have informa-

tion on foreign citizens only if those people have applied for services from the U.S. government.

However, the State Department's Fraud Prevention Unit *can* verify the authenticity of a visa for travel to the U.S. If you have any questions about whether a foreign national has—or has applied for—a visa, send the relevant details (including the traveler's name, home address, dates of travel, etc.) via e-mail to FPMM@state.gov.

> **One important point: There are no Russian or American customs or airline regulations requiring travelers show proof of income or "pocket money" to travel to the United States.**

Legally, there are two methods of bringing a mail-order bride into the United States:

1) Marry her abroad and then apply for a "Petition for an Alien Relative." The bride then has to apply for an Immigrant Visa as well. This is a conditional visa and the couple must remain together for at least two years before they can apply to have conditions removed.

2) A method that allows the potential bride more freedom is the fiancée visa. Under this permit, the American must file a petition with the ICE and the couple must marry in the U.S.

As we've mentioned, the couple must have met in person at least once in the previous two years before

filing. Once the fiancée visa is granted, the bride—and it usually is the bride immigrating—and her children may travel to the U.S.; she has 90 days to marry her prospective husband. If the couple has not married in 90 days, then the bride (and any children) must leave.

> The fiancée visa is the best way to proceed. It gives the couple the option of canceling before they marry, if either decides they don't suit each other.

WHO CAN RUN A BRIDAL AGENCY

There are no regulations restricting the operation of mail-order bridal agencies in the U.S., as long as the agency:

- abides by the Illegal Immigrant Reform and Immigrant Responsibility Act and any other ICE policies,

- is not committing fraud,

- is not involved in alien smuggling,

- is not involved with involuntary servitude—that is, slavery,

- is not involved in the importation of aliens for immoral purposes (that is, pimping prostitutes as fiancées) and

- is not establishing a commercial enterprise for the purpose of evading immigration laws.

Also, agencies must be careful not to offer too much visa assistance. According to U.S. regulations, a visa consultant or any other person who is not a licensed attorney may only assist someone with completing immigration forms and applications for a nominal fee—and cannot state that he or she is a qualified expert in immigration laws.

So, how can an ordinary person tell a legitimate bridal agency or person from a prostitution ring or a meth-addict scammer? The following points should raise suspicions:

- The foreign bride—or groom—contacts you first (scammers look for victims on free post-your-profile dating sites and buy lists of contacts from legitimate but shady matchmaking services).

- The person writes in fluent English.

- The person professes love for you quickly—within a few weeks.

- The person talks about how nice it would be to live in your country, instead to live with you.

- The person uses an Internet café and needs money to stay online.

- The person offers no postal address or phone number and evades questions involving personal information that you can verify.

- The person avoids or doesn't answer specific questions about where he or she lives, what he or she does...or personal or family history; he or she becomes

offended or insulted when you ask personal questions that could be verified.

- The person needs money for a visa or travel costs to visit you because his or her own savings are not enough.

Finally, there are a number of Internet-based Dating Agency blacklists (one is located at www.womenrussia.com/blacklist_summary.htm) that keep track of crooked schemes. But even the lengthiest of these blacklists are rarely complete. Your own common sense should be the best indicator of a crooked service.

SWEETHEART SCAMS

Of course, Russian brides aren't the only con revolving around loneliness and the promise or romance. Crafty scammers are ruthless and efficient at locating gullible women on dating sites (in many cases, Christian dating sites), romance novel chat rooms and other lonelyhearts hangouts online.

In the fall of 2004, a single middle-aged woman living in suburban St. Louis, Missouri, searched a reputable dating site where she found the profile of a middle-aged man looking for companionship. The two began exchanging e-mails which were friendly at first—but quickly grew more intense and passionate. Even erotic.

The man said he was from small town in the Midwest but that he was out of the country working on a big construction job. He was helping build a sports stadium in Nigeria. As soon as he returned home, he'd come visit woman. She couldn't wait.

Within a few weeks of the first e-mail, the woman started receiving gifts at home and at work—a box of chocolates, a teddy bear and a helium balloon that said "I love you."

The Internet romance progressed for another two months; and then there was a problem. The man said that his boss was paying him in postal money orders and that he was having trouble cashing them in a foreign country. Could the woman do a small favor for him? Could she cash a money order and wire the money to him in Nigeria? She agreed.

The money order arrived by mail, as agreed. And a few days later another one followed. The woman deposited the two money orders—each with a face value of $900—into her bank account, waited a couple of days for the funds to be available and wired the money to her gentleman friend in Nigeria.

He thanked her and said he was getting ready to come back to the States. He sent her his flight information. They kept swapping e-mails. Then, a few days later, he asked her to cash one more money order for him—so that he could fix a Nigerian visa problem and come home. He sent a third money order; she cashed it and wired the money.

A couple of days after that, the woman's bank called. Something was wrong. The money orders that she'd deposited in her account were fraudulent. They'd been altered—purchased for a face value of $20, then "washed" and doctored to read $900. Banking regulators were looking into the possible criminal angle; in the meantime, the bank was holding the woman liable for nearly $3,000 that she'd wired

to Nigeria. She had enough money, barely, in a savings account to cover the wires.

And she still was looking forward to her gentlemen friend getting back to the States and straightening out the whole mess. He said he would.

As the date of his planned return drew close, they talked in long detail about their lives together. Then, suddenly, his e-mail account was dead. She never heard from him again. And the banking regulators couldn't draw any useful conclusions from the altered money orders.

Sweetheart scams are embarrassingly easy to perpetrate—and victims often are too embarrassed to come forward when they've been scammed.

Crooks post ads to online dating sites and lurk in chat rooms with names like "40 and Single" or "Recently dumped." Some deliberately target groups set up for religious singles, where people are be less likely to be suspicious. Others are savvy about casting themselves as looking for a spiritual link with someone who "really understands" them.

The lines these crooks use are simple and predictable. They often reach out to lonely women with clichéd gifts like flowers or candy (sent to work or other public places).

Once the crooks have established a level of trust—what most call an *in*—they set about the scam. Cash-

ing bogus money orders or checks is a favorite device that the online Casanovas use; sometimes, they don't even say anything before sending the fake paper. The checks arrive at the sweetheart's home and the Casanova convinces the woman to wire the cash.

Another common scam is convincing the victim to set up a joint account with an Internet bank or retailer that allows the crook to withdraw or spend funds that the victim supplies. In many cases, these joint accounts will be started under the pretext of an investment or business venture.

In other cases, the crook isn't after money—but shipping help. He will ask his sweetheart to reship packages to locations (Nigeria is, once again, a favorite) to which online retailers refuse to send goods. In most cases, these goods are purchased with stolen credit cards or bogus demand drafts.

SWEETHEART SCAMMER TRICKS

One veteran sweetheart scammer conned a Washington state woman out of over $100,000 during a yearlong romance.

Norman Benoit—who had used the aliases "Dean Morgan," "Michel Benott" and others—moved to the Seattle area in the early 2000s, fleeing prosecutions in Texas and Montana for passing bad checks and various low-end thefts.

Benoit, who used the "Michel Benott" alias in Seattle, was in his 40s but looked and acted much younger than that. Like many sweetheart scammers, he frequented college campuses, libraries and other bookish locations—on the prowl for vulnerable women. In the fall of 2001, he met a divorced mother in her mid-30s who worked at a local college. She was a promising target.

The woman was excited that the tall, multilingual "Michel" was interested in her, a single mother. He said that he was a graduate student who worked irregularly as a free-lance translator. Indeed, he seemed to speak French and Vietnamese. He knew his way around several university campuses in the Seattle area; his apartment was the kind of shabby/genteel place that someone with good taste and a student's budget would have. He kept the frantic hours of a student.

Michel showed the sophistication and worldliness that a working, single mother found captivating. He seemed cultured and well-read. He knew a lot about things like gourmet food and rare coins.

That last bit was his con.

The girlfriend had some savings; Michel gradually talked her into investing in rare coins. Gradually—amid talk of getting married once he got his degree—he made a soft sell about coins as a conservative investment...yet one in which a smart person could make serious money. The girlfriend bit. She offered to let him put some of her savings into coins.

> He seemed most conscientious about her trust. He bought coins from reputable dealers and provided receipts for everything. She was satisfied...and trusted him with more of her money.

Months went by. The initial euphoria over the romance died down. The girlfriend began to take issue with Michel's strange hours and manic lifestyle. And he kept pushing her about putting more money in coins. But she didn't want to lose an attractive, intelligent boyfriend....

Finally, in the spring of 2003, he nudged her to buy more coins—and she realized that she'd put well over $100,000 into his suggestions. This was almost all of her savings. She confronted him about his strange hours and student's lifestyle. He acted hurt. And then he was gone.

In short order, the single mother found out that the coins "Michel" had bought for her were worth a fraction of what he'd claimed. The receipts were fakes. In some cases, they'd been altered to state higher values; in others, fabricated entirely. He'd scammed tens of thousands of dollars—the difference between the inflated values and what he'd actually paid.

The girlfriend hired a private investigator to find out who Michel really was. She went to the police with her paperwork. They filed criminal charges against Benoit—but admitted that they couldn't do much to track him down. His sweetheart scams were a low priority. Their best chance of finding

him was to pull him over for a traffic ticket to catch him in the act of some other crime.

SIGNS OF A SWEETHEART SCAM

The mechanics that sweetheart scammers use are not subtle or original. In fact, many victims—reeling from the money or property they've lost—look back on the "romance" and are ashamed that they fell for such stupid ploys.

The skill of the sweetheart scammer comes in saying and doing stupid things shamelessly to exploit a victim's vulnerability or weakness. So, the limited repertory of familiar tricks that sweetheart scammers use is worth considering...and repeating:

- "Us vs. Them" mentality. A sweetheart scammer will establish a sense of separation between the victim and his or her real financial and emotional supports. The scammer will make a big deal of how other people "don't appreciate" and "don't understand" the target.

- Bold talk/few details. A sweetheart scammer talks boldly and in broad strokes. He will be quick to tell a woman he loves her. He'll promise to marry her to "take her away" from a difficult life. But he won't do any of this...and get vague when pressed for details.

- Hiding behind "misunderstandings." Sweetheart scammers spend a lot of time talking; they'll also encourage the victim to talk. Amidst all of this talk,

crafty scammers will plant the seeds of confusion—teasing the mark for being unclear or criticizing themselves for being confusing.

- Hurried or broken communication. Despite all of the time spent talking, sweetheart scammers will often talk in hurried cadence or incomplete sentences. Victims will often "fill in the blanks" and infer things they want to hear—especially once they've decided to trust (or have sex with) the scammer.

- Trust games. Sweetheart scammers often make showy "points of principal" about trust. They will talk about having been abused by people they've trusted in the past; they will assign great significance to minor matters because they think "it's a matter of trust."

- Exploiting self-pity. Sweetheart scammers often talk about wrongs done to them or poor decisions they've made in the past—but make grand gestures of remaining optimistic or hopeful. In fact, these gestures are designed to appeal to self-pity that the victims feel.

AVOIDING SWEETHEART SCAMS

If you or someone you know plans to use Internet dating services to find romance, make sure that person considers taking the following precautionary steps:

- Don't post your regular e-mail address. Instead, use a "disposable" address routed through any of the major free e-mail providers (Hotmail, Yahoo, etc.).

- When posting your profile—or ad, depending on the jargon preferred by the service—give only general information about yourself. Don't include actual details about where you live or work.

- When you start getting responses to your profile, use extreme caution if a respondent brings up the subject of money.

- Be wary of respondents who quickly press you to "meet" them in other chat rooms or exchange instant messaging information.

- Never—under any circumstances— give anyone you "meet" online your banking account numbers, Social Security number, driver's license number, home address, phone number or credit card numbers.

- Before agreeing to meet anyone in person whom you've recently "met" online, get personal contact details (including name, physical address, telephone, etc.) from that person...and leave it with someone you trust. And—still—try to give as little information about yourself as possible.

One final note: Some sweetheart scammers specialize in targeting married people (most often, women).

So—no matter how flawed your marriage—be wary of any person who presses you for an intimate relationship when they know you're married. Don't be drawn in when someone you barely know starts talking about how your spouse doesn't appreciate you. Especially before *you've* said anything of that kind.

It's an irony of the wired age that some people feel lonelier than ever. Sweetheart scammers and crooked marriage agencies are ruthless about exploiting that loneliness.

8

DRUG, DIET AND PHARMACEUTICAL SCAMS

Fraud consumes between three and 10 percent of the $1.7 trillion that Americans spend on medical care each year—and the fast-growing parts of that fraud involve bogus diets and illegally-distributed or simply fake pharmaceuticals.

Drug scams are the result of many factors. Direct-to-consumer drug advertising (which barely existed in the early 1990s) has made consumers open to drug marketing campaigns—legitimate or not.

And then, of course, there's spam.

During 2004, pharmaceuticals overtook pornography as the leading subject for spam on the Internet. If you use the Internet at all, you've probably noticed that the preponderance of sleazy e-mail subject lines has changed from variations on "Hot Girls, Click Here" to variations on "Viagra/No Prescription Needed, Click Here."

While this analysis may not be quite as scientific as double-blind research from Harvard Med, it does have support from several serious sources. In April 2004, the Clearswift Spam Index placed pharma-

ceutical spam above spam offering either porn links or bogus financial advice. Specifically, the Clearswift report found that:

- 40.0 percent of spam was healthcare or pharmaceutical related,

- 37.8 percent was for financial advice,

- 4.8 percent was pornography.

A major challenge to drug spammers: filter settings that automatically reject e-mails containing trademarks for popular drugs like Viagra and Cialis. So, the most enterprising crooks replace certain letters in those words with look-alike symbols. That's why you see so many e-mails that read:

> *All products for your health! An amazing variety of licensed meds at one big store! Click the link and make your first step to constant relief!*
>
> V1agra Soft Tabs
>
> V1agra Professional
>
> C1al1s
>
> Generic V1agra
>
> Lev1tra

"V1agra" instead of "Viagra." And "Lev1tra" instead of "Levitra." These variations last a while—until a critical mass of spam filters reject the altered versions. Then, the crooks have to find new alterations.

ONE INTERNET DRUG KINGPIN

In January 2005, a federal judge in San Diego sentenced Mark Anthony Kolowich to serve a prison term of 51 months and forfeit "substantial cash pro-

ceeds" for operating one of the largest and most crooked Internet pharmacy scams ever prosecuted.

A few months earlier, Kolowich had pleaded guilty to conspiring to sell counterfeit pharmaceuticals, commit mail fraud and conspiracy to launder money. In a separate (but related) case, he'd pleaded guilty to conspiring to import unapproved drugs into the United States, introducing those drugs in interstate commerce and smuggling unapproved drugs into the United States.

In his heyday, Kolowich owned and operated a Web site at www.WorldExpressRx.com. From that site, customers could order prescription drugs without having a prescription. The site directed the customer to fill out a questionnaire and pay a $35 fee for a "doctor's consultation."

> The Web site stated that a doctor would review each questionnaire and issue a lawful prescription before drugs were shipped to customers. However, there was no doctor employed by—or otherwise associated with—WorldExpressRx.

The pharmaceuticals Kolowich sold through the site included tablets and capsules containing the active ingredients for Viagra, Cialis, Levitra, Propecia, Celebrex and Xenical. WorldExpressRx marketed its products as "generic" versions of the respective drugs; in fact, no generic versions of those drugs were available in the U.S. at the time.

How was Kolowich able to import these illegal generics? Thanks to the global economy. He contracted with small laboratory in Mexico to manufacture the pills from ingredients he bought and had shipped in from China and India. Independent "contractors" smuggled the phony drugs across the border into California, where WorldExpressRx employees packaged and sent them to customers throughout the United States.

Not everything was built from scratch. Kolowich also had contractors smuggle legal (but unapproved for sale in the U.S.) Viagra up from Mexico. This he sold as "real" Viagra.

> **Kolowich was quite entrepreneurial. In addition to smuggling in fake drugs and marketing them online, he built an efficient system for processing customers' credit card and debit card orders. In fact, from this smooth operation, he set up a company called World Express Processing (WEP).**

WEP offered its services, for a fee, to other Internet pharmacies which were unable to get traditional banks to handle their processing. At its peak in 2003, WEP received about $1 million per month from credit card charges—about half of which came from WorldExpressRx sales and half from other online pharmacies.

One of the Internet pharmacies that used the services of WEP was Florida-based MyRxForLess.com. From December 2002 to March 2004, more than

$1.7 million in payments for credit card purchases from the MyRxForLess Web site were processed through WEP.

MyRxForLess.com also learned other tricks from Kolowich's operation. It advertised prescription drugs with "no prescription needed." It purchased "generic" Viagra and "generic" Cialis from Kolowich. (In November 2004, the husband and wife who owned MyRxForLess.com were arrested in Florida.)

In addition to everything else he was doing, Kolowich set up a system to have unapproved drugs made in India and Pakistan enter the United States via a second channel—the Bahamas. He worked with crooked contacts in Miami and the Bahamas to import counterfeit Viagra.

But the Feds were onto Kolowich by this time; and he was getting careless about his deals. In September 2003, more than 900 packages from the Bahamas connection were intercepted in Miami; government agents seized some 1.6 million pills, valued at approximately $9.8 million, in that bust.

The Miami bust marked the beginning of the end for Mark Kolowich and WorldExpressRx.

After Kolowich was sentenced, U.S. Attorney Carol Lam tied the whole episode back the FDA's preferred public policy statement:

Consumers need to be aware that many of the safeguards that exist for bricks-and-mortar pharmacies do not exist for Internet pharmacies.

HOW INTERNET PHARMACIES WORK

There are four basic types of Internet pharmacy. There are those that:

1) are partners with traditional brick and mortar pharmacies (such as the online firm drugstore.com and Rite Aid);

2) are themselves brick and mortar pharmacies (such as cvs.com);

3) operate solely on the Internet (such as planetrx.com); and

4) operate Web sites, usually based outside the United States, where consumers can order prescription drugs without a prescription.

Some of these Internet pharmacies are reputable and above board, while other so-called "rogue" sites may sell medications that are close to the expiration date—or have already expired. Rogue operators may have multiple Web addresses and provide "services" of a dubious nature.

According to the National Association of Boards of Pharmacy (NBPA):

...As for increased privacy and confidentiality, evidence appears to indicate that illegitimate prescribing sites frequently sell their customer lists to other illegitimate online pharmacy operators and

owners of Internet scam and pornography sites. By buying drugs from an illegitimate site you may be designating yourself as someone who is a good target for rip-off schemes.

Some Internet pharmacies employ a questionnaire as the sole basis for providing prescriptions. The FDA presents the following advisory regarding this practice:

> *Unlike the traditional relationship between a patient and the patient's health care professional, some online practitioners issue prescriptions in the absence of a physical examination or direct medical supervision.*

According to the American Medical Association, a health care professional who offers a prescription for a patient he has never seen before and based solely on an online questionnaire generally has not met the appropriate medical standard of care.

As a result, the online patient may receive a drug that is inappropriate or may not get a correct diagnosis or may have an underlying medical condition ignored.

MORE PATCHWORK REGULATION

As we've seen in other contexts, crooks gravitate to Internet pharmacies because the industry is not regulated uniformly.

In the U.S., online pharmacies are regulated by state boards of pharmacy—there's no (or very little) federal oversight.

> One place where there is some federal oversight of online pharmacies is in the matter of requiring valid prescriptions in order to sell certain drugs.

It is a violation of the Federal Food, Drug and Cosmetic Act to dispense prescription drugs without a valid prescription.

In addition, several state boards of medicine have ruled that such practice is medical misconduct and have fined and suspended the licenses of doctors and other health care practitioners who prescribe drugs in this manner.

At a September 2005 press conference in Dallas, Texas, Drug Enforcement Administration head Karen Tandy announced the culmination of Operation CYBERx, a multi-faceted Organized Crime Drug Enforcement Task Force (OCDETF) investigation targeting major alleged pharmaceutical drug traffickers operating in the United States.

The DEA and its enforcement partners arrested 18 people for allegedly selling pharmaceutical drugs illegally over the Internet. Those people ran more than 4,600 rogue pharmacy Web sites.

Most of these rogue pharmacies received prescription orders for controlled substances over the Internet, which were then shipped to the doors of the customers—sometimes without any prescription required. And the rogue sites averaged more than $50,000 a day in profits.

Drugs that are considered prescription drugs under the FDCA may be distributed only with a valid prescription under the professional supervision of a licensed practitioner. A prescription drug is considered "misbranded" if it is not dispensed under a valid prescription in accordance with the law.

> **Introduction or distribution of misbranded drugs into interstate commerce violates the FDCA. An online pharmacy that provides prescription drugs without a prescription would therefore be in violation of this law.**

ANOTHER DRUG COUNTERFEITER

In September 2005, U.S. Attorney Chuck Rosenberg announced the indictment and arrest of Richard Cowley of Shelton, Washington. The Feds alleged that Cowley had been illegally importing and distributing counterfeit drugs—including Viagra, Lipitor and Cialis—made in China.

Cowley was arrested by agents of the U.S. Immigration and Customs Enforcement (ICE) with a warrant issued following a six-count federal indictment. (He was later released on bond.)

Simply said, Cowley was accused of importing pharmaceutical drugs bearing registered trademarks without authorization of the holders of those marks. (Viagra and Lipitor were trademarks of Pfizer Pharmaceuticals; Cialis was a trademark of the Eli Lilly

Corporation.) He was also charged with selling mis-branded versions of the same drugs.

Under U.S. law, a prescription drug is deemed to be *misbranded* if its labeling is false or misleading in any particular manner. A prescription drug is deemed to be *counterfeit* if it bears a trademark without the authorization of the trademark owner.

Crowley faced more than 10 years in prison and more than $250,000 in fines. The charges were the result of an undercover operation conducted by ICE special agents, based on information provided by the ICE Attache office in Beijing, China, regarding an Internet Web site called "bestonlineviagra.com."

The site was allegedly owned and being used by Cowley to distribute bulk quantities of counterfeit Viagra and Cialis manufactured in China.

After some preliminary investigative work, the undercover investigation led to a number of e-mail exchanges via an msn.com address provided by Cowley to the undercover agent—and, eventually, to the online purchase of counterfeit drugs.

In June 2005, the undercover agent placed an order for 1,000 Viagra and 1,000 Cialis tablets for $3,650 and 20-milligram sample tablets of Lipitor in bottle and blister pack with Pfizer labeling and packaging for $100. The online order was delivered via FedEx to an office in Houston, Texas.

Laboratory analysis conducted by the Food and Drug Administration of the Viagra and Cialis tablets proved to be counterfeit.

At the same time Crowley was arrested, the Feds grabbed various computers and paperwork in his home—in hope of establishing clear links to his suppliers in China.

COUNTERFEIT DRUGS & DIETS

The FDA's primary mission is to protect the public health. With regard to drugs and pharmaceuticals, it focused on three specific areas of enforcement:

1) counterfeit drugs,

2) Internet health fraud (dietary supplements, including weight-loss pills), and

3) misleading promotion (off labeling warnings).

Counterfeiting of drugs is commonplace around the world. In some countries, you are more likely to get a counterfeit product than an authentic drug.

Traditionally, the U.S. drug supply has been among the safest in the world—relatively free of counterfeits. However, beginning in the early 2000s, regulators have seen a significant increase in counterfeit activities for high-cost drugs.

These counterfeits can *look* authentic. FDA enforcement agents believe drug counterfeiting networks are increasingly well-funded and sophisticated about using technology to copy drugs.

> The FDA can't provide consumers with assurance
> that drugs purchased over the Internet are made
> under good manufacturing practices (GMP) require-
> ments—even if the Web site is based in the U.S.

FALSE MIRACLE DIETS

The FDA has also focused on dietary supplement manufacturers who make false or misleading claims about their products, espeically with regard to weight loss.

In this effort, the FDA and the Federal Trade Commission formed a Dietary Supplement Enforcement Group to coordinate enforcement efforts. As part of the group's effort to curb Internet health fraud, FDA has conducted several "surfs" (its term for Internet stings) to identify fraudulent marketing of health care products—including dietary supplements.

For example: In October 2004, the FDA's Center for Food Safety and Nutrition sent nine warning letters to dietary supplement manufacturers for unsubstantiated claims about dietary products.

One of these letters—sent to a Florida-based company called Bionutricals International—stated:

> *The Food and Drug Administration (FDA) has reviewed your web site...and has concluded that claims on this web site cause your products CarboGetic, Metabo Fat Blocker and Extreme Carb Blocker to be misbranded under the Federal Food, Drug, and Cosmetic Act (the Act). ...The*

labeling of CarboGetic, Metabo Fat Blocker and Extreme Carb Blocker bears structure/function claims, including the following:

CarboGetic:

"[A] product that inhibits the absorption of carbohydrates while increasing your energy levels to burn more fat and carbs. ...Blocks carb absorption via alpha-amylase inhibition ...Helps reduce sugar cravings ...Controls carb cravings."

Metabo Fat Blocker:

"Metabo Fat BlockerTM ... can bind to dietary fat and provide a feeling of fullness— thus suppressing the appetite. ...[O]n average, most people who weigh 180-260 pounds can lose about 7-10 pounds a week with our Metabo Fat Blocker."

Extreme Carb Blocker:

"Extreme Carb Blocker helps you reduce starch calories by blocking alpha-amylase.... [T]he undigested starch and its calories simply pass through the body undigested. ...[I]nhibits the absorption of carbohydrates and sugar. ...Helps reduce sugar cravings ...Controls carb cravings..."

We have reviewed these claims and have concluded that they are not supported by competent and reliable scientific evidence. Because these claims lack substantiation, they are false or misleading....

In the course of its investigations, the FDA found that many Internet sites were comprised of multiple related sites and links, making regulation more

complex and resource-intensive. The global nature of the Internet also creates special problems for effective law enforcement.

The FDA has investigated and referred cases for criminal prosecution and initiated civil enforcement actions against online sellers of drugs and dietary supplements. But diet supplement makers tend to get administrative warnings rather than criminal prosecutions.

PRESCRIPTIONS WITHOUT EXAMS

In late 2005, Illinois resident Craig Schmidt sued two doctors who'd prescribed him antidepressants through an Internet pharmacy.

Schmidt ordered the prescription drugs online, filling out a medical questionnaire. He noted that he felt stress and mild depression. The doctors, who were in other states (Pennsylvania and New Jersey, to be precise), reviewed Schmidt's questionnaire. One wrote a prescription for Xanax and the other for Ultram—both anti-depression treatments.

> **The pills came in the mail and Schmidt took them, following instructions on the packaging.**

The next thing he remembered was waking up in a suburban Chicago hospital two weeks later. He'd suffered brain damage after taking the drugs. Apparently, the drugs were real—that is, they weren't counterfeit—though the dosages in them may have been different than indicated.

Illinois allows doctors to prescribe drugs over the Internet. So, Schmidt's online purchase was legal.

When an online prescription goes wrong, Illinois officials send complaints to the state medical board. And patients can sue in civil court. This is what Schmidt did; and he had to file suit in federal court, since the doctors who'd prescribed the drugs were in other states.

The Pennsylvania doctor who prescribed the Xanax settled his portion of the lawsuit. The New Jersey doctor accused of prescribing the Ultram insisted that, although his name was on the prescription, he was not the doctor who'd prescribed it.

Attempts to stop doctors from issuing prescriptions without physical exams have not been successful. State medical boards often have limited resources for enforcement. Only a handful of states have passed laws to address online prescribing. And prosecuting or taking legal action across state lines is difficult—if not impossible.

The speed, ease and anonymity of ordering products on the Internet attract unscrupulous sellers. People not licensed to sell prescription drugs can easily create Web sites that appear to represent legitimate pharmacies. And they can change the location and appearance of their sites quickly.

More than many other types of e-commerce, the unauthorized sale of prescription and unapproved

drugs poses a potential threat to the health and safety of consumers.

In situations where a customary physician/patient relationship does not exist, the online patient may be practicing what amounts to self-diagnosis.

A GLOBAL BLACK MARKET

An increasing part of online drug distribution is conducted by firms operating outside of the United States. Some of these offshore sites sell prescription drugs approved by the FDA without a prescription; some sites sell drugs that have not been approved for sale in the U.S.; and other sites sell drugs that are classified as Controlled Substances.

Under U.S. law, it is illegal for a foreign-based online pharmacy to sell prescription drugs to consumers in the U.S. without a prescription.

Although FDA has jurisdiction over a resident in a foreign country who sells in violation of the FD&C Act to a U.S. resident, from a practical standpoint the Agency has a difficult time enforcing the law against foreign sellers.

After the 9/11 attacks, the anthrax antidote Cipro jumped to the top of the list of medications sold illegally on the Internet. It was featured on many

sites and promoted more vigorously than Viagra. On many sites, it was the only drug sold.

A few years later, in October 2005, Swiss drug maker Roche urged consumers not to buy its flu drug Tamiflu over the Internet to avoid the risk of purchasing counterfeit pills.

> With experts predicting that millions could die if the bird flu strain H5N1 mutates into a human flu virus, some consumers appear to be building up their own reserves of the drug.

Roche, the maker of Tamiflu, warned consumers not to buy the prescription-only pill over the Internet but to get advice from their doctors and pick the drug up from a reputable pharmacy.

WHAT TO LOOK FOR...AND WHY

So, what are the signs of a *non*-reputable online pharmacy?

1) Online pharmacies are suspect if they dispense prescription medications without requiring the consumer to mail in a prescription, and if they dispense prescription medications and do not contact the patient's prescriber to obtain a valid verbal prescription.

2) Online pharmacies are suspect if they dispense prescription medications solely

based upon the consumer completing an online questionnaire—without having a preexisting relationship with a prescriber and an in-person physical examination. State boards of pharmacy and the AMA condemn this practice and consider it to be unprofessional.

3) Online pharmacies should have a toll-free phone number as well as a street address posted on their site. If the pharmacy merely has an e-mail feature, so that the sole means of communication between the consumer and the pharmacy is e-mail, it's a suspect site.

4) Legitimate sites allow consumers to contact pharmacists if they have questions about their medications. If a site does not advertise the availability of pharmacists for medication consultation, it should be avoided.

You can—and should—be cautious when purchasing drugs online. The hard fact is that there's no foolproof way of checking a site's reliability.

You can check with the National Association of Boards of Pharmacy to see whether the online pharmacy you're using has a valid license. Of course, just because a company has its license doesn't mean it's trustworthy. Sometimes, crooked firms have all of their paperwork in order.

But if it's a site that can't be verified—such as an overseas site—avoid it.

9

PHONES

Crooks and swindlers love telephones. Since phones became commonplace in the 1920s, bad guys have used them as essential tools in perpetrating frauds.

Today, there are two major ways crooks can use telephones to hurt you:

1) using phones—land lines or cell phones—to hook you into some kind of fraudulent financial transaction;

2) exploiting the technology of the phone hardware (and software) to steal your personal information or charge phone services to your accounts.

The first type of fraud exists in the telemarketing industry; the second exists around the world of computer hacking and viruses. In this chapter, we'll consider both types of phone frauds.

TELEMARKETING FRAUDS

Law enforcement agencies define telemarketing fraud operations by the principle medium of con-

tact used to perpetrate the scams. In other regards, they're just like Internet or affinity scams.

> There's a lot of confusion with these types of scams because they blend easily with legitimate telemarketing operations and call centers which, though often annoying, are not illegal.

Telemarketing frauds may consist of a single individual, a complex call center (that may also do legitimate work) or a temporary office set up with a bank of phones. This last setup is what crooks and law enforcement agencies call a "boiler room."

Whatever the structure of the phone system, the scam usually falls into one of two categories:

1) Outbound schemes involve solicitation calls made from lists of leads or at random, without any prior contact (by physical mail, e-mail or otherwise).

2) Inbound schemes involve consumers who've been encouraged to call a number. Once they call that number, they're drawn into a fraudulent transaction.

In 2004, the U.S. Federal Trade Commission estimated that more than 14,000 fraudulent telemarketing businesses operate in North America at any given period. Many of these operations take extensive measures to avoid any sort of investigation or prosecution. These measures include:

- using cell phones (sometimes in conjunction with prepaid telephone debit cards), which can be discarded after several weeks of intensive use;

- using stolen identities or legal documents to open mail drops for receipt of payments that victims mail them;

- using multiple mail drops that shuttle victim-related mail through multiple destinations;

- impersonation of law enforcement officers, to make victims believe that law enforcement is aware of their losses;

- contracting with other boiler rooms to do their work; and

- laundering of fraud proceeds through foreign bank accounts.

Historically, telemarketing fraud was perpetrated by a loose underworld of confidence artists who moved around constantly. However, starting in the 1990s, law enforcement agencies started seeing an increased involvement of organized crime.

> A favorite premise of telemarketing fraud: Credit cards for people with poor credit. Scammers promise vulnerable people a premium credit card in exchange for a one-time "membership payment."

Thousands of Americans—mostly people with bad credit and heavy debts—are lured by the promise

of a new credit card and a "fresh start" for their finances. Fraudulent telemarketers will often set up firms with names that sound like well-known financial institutions (Bank of The Americas, First Capitol Financial, Beneficial Guarantee Corp., etc.).

A telemarketer will hook a victim with smooth talk and big promises and then work quickly to get the victim's address and bank account information. In many scams, the victim will then be transferred to a "supervisor" or "verification officer" who confirms the bank information and the victim's permission for funds to be debited from his or her account.

This second conversation will often be recorded by the telemarketing company as proof of the victim's permission. Pointedly, the "supervisor" (who is usually just another telemarketer...with no particular supervisory authority) will not repeat any of the promises that the first scammer made.

Money is quickly debited from the victim's bank account to cover various "application" or "administrative" fees; but the promised credit card is another matter. Sometimes the victim never gets anything; more often, he gets an "information package" that includes coupons of little value and instructions for applying elsewhere for credit cards.

Many times, the same victims fall for numerous scams. Shady telemarketers build up and sell so-called "sucker lists" of people who have fallen for misleading pitches.

In August 2002, a Missouri-based company called American Capitol/First Beneficial Credit was sued by the U.S. Federal Trade Commission in connection with more than 450 consumers who received misleading credit card offers.

> The frauds are usually high-volume operations, with outbound callers hired by the dozens and trained to talk to scores of people a day. Even if the callers don't start out as hardened criminals, they quickly develop a cynical view about their victims.

As one telemarketer told a newspaper: "As far as I'm concerned, if you're stupid enough to give me your account number, you deserve to get screwed."

BOGUS AREA CODES

Another common phone scam is one that starts from obscure area codes. Sometimes these calls start from Caribbean Islands...sometimes they start in Toledo or Tacoma and route through the exotic locations.

In December 2004, the Federal Trade Commission warned U.S. residents to be wary of responding to unsolicited e-mails, phone calls, numeric pages or voice mail messages that direct them to an 809 or 823 area code.

This telephone scam can catch consumers off-guard, since these are legitimate area codes in the Caribbean. The exception is that they operate like 900 numbers in the continental U.S.

Typically, these messages encourage victims to call back on an important matter, such as a prize win or family medical emergency. People who return the calls are charged international call rates on their telephone bills.

To block telemarketing calls for five years, you must register via cell phone or online with the National Do Not Call List. To register:

1) Call this number from your phone: 1.888.382.1222, or

2) go to this Internet Web page: https://www.donotcall.gov/register/reg.aspx

CLONED CELL PHONES

A soon as we move into the field of telecom *technology* scams, a major issue is the cloning of cellular telephones. This is a relatively simple procedure that can be done with the purchase of over-the-counter electronic equipment.

When you use a cellular telephone, the device emits a burst of electronic information. Within this burst of information is the electronic serial number (ESN), the mobile identification number (MIN) and other electronic identification signals, all of which can be illegally captured through the use of an ESN reader.

Once captured, this information can be transferred through a computer onto microchips in other cellular telephones. These new telephones can be used for up to 30 days before the fraudulent charges are discovered.

Cloned cell phones are being used extensively by organized criminal groups and drug cartels, as well as several Middle Eastern groups.

The U.S. Secret Service has become the recognized law enforcement expert in the field of telecommunications technology fraud. These investigations often involve other criminal enterprises— such as access device fraud, counterfeiting, money laundering and drug trafficking.

INTERNET PHONE CALLS

Internet phone services have drawn millions of users looking for rock-bottom rates. In the Spring of 2005, they were also attracting identity thieves looking to turn stolen credit cards into cash.

Some Internet phone services allow scam artists to make it appear that they are calling from another phone number—a useful trick that enables them to pose as banks or other trusted authorities.

The scams underline the lower level of security protecting Voice Over Internet Protocol (VoIP), the Internet telephone standard that has upended the telecommunications industry in the early 2000s.

Traditional phone networks operate over dedicated equipment that is difficult for outsiders to penetrate. Because VoIP calls travel over the Internet, they cost much less but are vulnerable to the same security problems that plague e-mail and the Web.

Unscrupulous telemarketers can use VoIP to blast huge numbers of voice messages to consumers, a technique known as SPIT, for "spam over Internet telephony." You may recognize SPIT when you pick up a ringing phone and hear a recorded voice asking you to "return this very important phone call."

Caller ID spoofing has emerged as another useful tool for identity thieves and other scam artists.

An important point: Caller ID spoofing is not prohibited by law. But the Federal Communications Commission requires *telemarketers* to identify themselves accurately. This is a rather narrow requirement. Debt collectors and private investigators use various "camophone" services that trick Caller ID software and convince people to answering the phone when they otherwise might not.

Criminal uses of caller-ID spoofing have become common. Specific examples of these uses include:

- Wire-transfer services like Western Union require customers to call from their home phone when they want to transfer money in an effort to deter fraud—a barrier easily sidestepped by any identity thief using a caller—ID spoofing service.

- Crooks can use caller-ID spoofing to listen to other people's voice mail, especially when those accounts are not protected by passwords.

- Crooks use the technology to make it appear that they're calling from a bank or other financial institution. That helps them convince consumers to divulge account numbers, passwords and other personal data.

CELL PHONE VIRUSES

In February 2005, the world's first cell phone virus "in the wild" spread to the United States from its birthplace in the Philippines eight months earlier. The virus, called Cabir, marked the arrival of a new tech scam.

The biggest impact of the relatively innocuous virus was draining cell phone batteries. But, once hackers perfect cell phone access, they'll start looking for useful information to steal or exploit.

> **Exports predict that cell phone virus threats will grow in the future as virus writers become more sophisticated and phones standardize on technologies that make it easier for viruses to spread throughout the industry.**

Unlike computer viruses that spread quickly around the world via the Internet, Cabir spread slowly because it traveled only over short distances through a wireless technology known as Bluetooth. It also requires a user to restart the phone after it had been exposed for the virus to take hold.

In cases where Cabir spread to different countries, an infected phone has typically been carried by the user to another country. Cabir has been found in countries ranging from China to the U.K.

HACKED CELL PHONE ACCOUNTS

In February 2005, a young hacker who broke into the cellular telephone network of T-Mobile USA Inc. and accessed personal information on hundreds of customers—including a Secret Service agent—pleaded guilty to a felony hacking charge. The case showed how vulnerable cell phones can be.

Nicholas Lee Jacobsen was a 19-year-old living in southern California when he first hacked into Bellevue, Washington-based T-Mobile USA's computer network. As a result of his attack, Jacobsen was able to view the names and Social Security numbers of about 400 T-Mobile customers. (The company said customer credit card numbers and other financial information were not exposed.)

Jacobsen was also able to download e-mail account passwords and voicemail PINs. Using these, he spied celebrity e-mails that included photographs taken with camera phones. He boasted to friends that he was able to access private pictures of Demi Moore, Ashton Kutcher and Paris Hilton.

At one point, he even boasted on an online bulletin board that he could look up the name, Social Secu-

rity number, birth date and passwords for voice mails and e-mails for T-Mobile customers.

By these accounts, it seemed that Jacobsen was an old-fashioned hacker—more interested in bragging about celebrity pictures than taking money.

Eventually, a broad-scale investigation into cell phone hacks by the U.S. Secret Service discovered Jacobsen's work. But even *that* investigation didn't foil him immediately.

In fact, Jacobsen—who knew that the Secret Service was investigating him—found T-Mobile cell phone account information for a Secret Service agent. The agent, Peter Cavicchia, was also a T-Mobile customer and sometimes used the wireless network to communicate about the case, unaware that his account wasn't safe.

Jacobsen downloaded an internal Secret Service memo and other information sent by Cavicchia over T-Mobile e-mail systems.

According to Secret Service spokesman Jonathan Cherry:

> *It's true that a personal account of a Secret Service agent, for a time, was compromised. It was not Secret Service servers, it was a personal account, a PDA. The account did have very limited investigative materials in it which should not have been kept on a personal PDA.*

Cavicchia later resigned from the Secret Service to work in the private sector.

Jacobsen was arrested in October 2004 as part of Operation Firewall, a Secret Service sweep of alleged cyber-criminals that netted at least 28 suspects. He faced up to five years in federal prison and a $250,000 fine.

INSTANT MESSAGING VIRUSES

With Internet service providers filtering e-mail, hackers have turned their attention to the popular and not very secure instant message (IM) services used by millions of Americans.

In March 2005, an IM worm called Kelvir appeared, with several variants occurring almost immediately.

Kelvir used a simple message in Microsoft's MSN Messenger chat tool (using popular short-hand phrases like "lol! See it! You'll like it!" and "omg this is funny") to fool users into linking to a Web page infected with a Trojan. That link, in turn, downloaded a malicious file—the actual worm, a variant of the long-running Spybot—which opened a backdoor to the compromised machine.

An infected user immediately sent copies of the worm to fellow chatters; and they'd have the worm installed on their systems.

> The pitch was effective because it would often appear in mid-conversation between two chatters actually swapping IM messages. One—or both—would be convinced that the link was sent by the person with whom they were chatting.

One reason that hackers pick on Microsoft's IM system is that it can be accessed through source code embedded in the Windows operating system. These bits of programming allow experienced hackers a way to take over an MSN Messenger client.

In April 2005, Reuters Group was forced to shut down a popular privately-controlled instant messaging service for a short time after a Kelvir variation affected some of the network's users.

The worm was first detected on the Reuters network on a Thursday morning; the company suspended the service five hours later.

The Reuters system was a logical first location for the problem. It was very popular among traders in the financial markets; it had more than 60,000 active users during peak hours. The worm generated a flood of instant messages, which slowed down the Reuters network for legitimate traffic.

People running anti-virus and firewall systems were protected from the worm, which only affected "a handful" of Reuters clients, the company said. Technicians had restored the IM service within 48 hours.

The damage done by viruses like Kelvir is limited by the fact that they rely on the user to click on the link the infected Web site. Once that Web site is removed from the Internet, the worm no longer operates; and Internet service providers remove Kelvir Web pages as quickly as they are identified.

About the same time that the Kelvir variant was wrecking havoc on Reuters' IM system, another worm—called Sumon—was discovered spreading via MSN Messenger. Sumon was much more aggressive than Kelvir. It disabled security software and overwrote Web access files so that standard security Web sites couldn't be reached.

In late 2005, security experts were concerned that hackers and virus writers had taken a fancy to IM tools. This wasn't a new warning; security firms had been predicting IM worms for more than a year.

But their predictions hadn't done much to prevent the problems. During 2005, Worms had appeared on all three major IM systems—Microsoft's MSN Messenger, Yahoo's Messenger and American Online's AIM.

> **The best preventive measure is to assume that links in instant messages are bad until proven otherwise. Users need to be extremely skeptical when clicking on links sent over IM systems—even if they appear to be from people you know.**

Most tech security experts expect to see more worms targeting the instant messaging and chat applications. And they predict that, in time, IM virus writers will find a way to make the programs spread on their own—without requiring a recipient to click on a link. If this happens, corporate computer and phone systems could become infected in a matter or seconds.

CHAPTER

10

HACKERS

In January 2005, a federal court in Washington state sentenced Jeffrey Lee Parson to 18 months in prison for unleashing an Internet worm that had crippled at least 48,000 computers over several weeks during 2003. Parson—who was 19 years old when sentenced—would serve his time at a low-security prison and also perform 10 months of community service.

Parson fit the image most people have of a computer hacker. He was an overweight, socially awkward teen—a typical "script-kiddie," who makes trouble online and then boasts about it to anyone who'll listen. In this case, Parson had created a variant of the Internet worm called Blaster which attacked computers using Microsoft Windows.

At trial, Parson apologized to the court and to Microsoft, saying, "I know I've made a huge mistake and I hurt a lot of people and I feel terrible."

This statement hints at the self-centeredness of hackers (and other scam artists). Four *I*'s in 18 words—and the whole thing ended with how he felt.

Several months later, a German criminal court had to consider a similar case. Judges in the city of Verden were more lenient with 19-year-old Sven Jaschan, who'd unleashed the Sasser Internet worm.

Jaschan was found guilty of violating German laws designed to combat the writers of computer viruses-but he received a two-year suspended sentence, which meant no jail time.

The Sasser worm had caused more harm than the American kid's Blaster variant. It exploited a flaw in Microsoft's Windows 2000 and Windows XP operating systems; it would cause some computers to crash repeatedly. But the German court said it went easy on Jaschan because he'd "acted out of a need for recognition" and not for financial gain.

> **Today's hackers are more dangerous than the desperate boasts of childish geeks like Parson and Jaschan. The familiar script kiddie is giving way to more ruthless and money-driven villains.**

About the same time that Parson and Jaschan were being sentenced, word began circulating in Internet security circles about so-called "ransom-ware" or "cyber extortion" schemes.

The mechanics of the schemes were simple enough: Hackers create a virus that encrypts certain files a computer's hard drive, so that the rightful user can't access them. Instead, the only thing the user can see is a taunting message that gives instructions for

sending a ransom (often as little as $200...but higher, sometimes) in exchange for a code that will unlock the files.

Ransom-ware schemes usually start when a user visits a vandalized Web site. (The site owner often doesn't realize that crooks have hijacked part of the site.) When the user views an infected page, the ransom-ware virus loads onto his computer.

> The infection locks up specific types of data files—usually databases and spreadsheets—and leaves notes with instructions to contact an Internet address to purchase "keys" that will unlock the files.

Law enforcement agencies usually focus on grander schemes, in which organized groups of hackers threaten to attack big commercial Web sites and steal customer data unless the companies pay them hundreds or thousands of dollars.

An example of that kind of scheme: In November 2004, a mobile phone virus program known as "Skulls" was sent to security firms—not consumers—as threat of trouble to come. Hackers call these limited releases of their weapons "proof of concept" hacks. The hacks prove the virus' capability.

HACKERS GROW UP

The growing professionalism of hackers is changing the way security experts look at viruses, Trojans and the general category of what they call "mali-

cious code." Between 2003 and 2005, Symantec Corp. saw a steady move among hackers from attacks designed to establish notoriety toward attacks designed to steal money. Attacks on confidential data—such as credit card numbers, passwords, and encryption keys—increased from less than one quarter to more than three-quarters of all reported hacks.

In the fall of 2005, Symantec's twice-a-year *Internet Security Threat Report* concluded that the number of new viruses targeting Microsoft Windows users jumped 48 percent to nearly 11,000—in six months. The report also found that viruses exposing confidential information made up three-quarters of the top 50 viruses, worms and Trojans.

More robot (or "bot") networks—created when a hacker gains control of a large number of computers—were available for sale or rent in the underworld of the Internet, Symantec said. A "botnet" is a collection of hacked computers at the disposal of a hacker without the owner's knowledge. Botnets are commonly used to launch distributed denial of service (DDoS) attacks or to send spam.

The Symantec report predicted:

> *As financial rewards increase, attackers will likely develop more sophisticated and stealthier malicious code that will attempt to disable antivirus, firewalls, and other security concerns.*

Symantec saw an average of 10,532 active bot network computers per day, an increase of more than 140 percent from the prior six months.

Symantec's *Internet Security Threat Report*s are based on information from the company's customers and from its global DeepSight Threat analysis system.

The Fall 2005 report found that hackers were increasingly using backdoors—pieces of viruses that lay dormant on computers, even after the computers have been cleared of the main virus. These dormant pieces allow hackers to return later and take over the infected computer again, without having to fool the user into giving access.

The number of worms and viruses reported to Symantec that targeted backdoors to plant new code jumped almost three-fold between 2002 and 2003.

The wave of worms that computer security experts saw in 2004 was largely the result of pre-published source code for viruses like Netsky and MyDoom—as well as related backdoor viruses like Doomjuice. These hacks can result in significant financial loss, particularly if credit card information or banking details are exposed.

Other Symantec findings included:

- Denial-of-service attacks grew from an average of 119 per day to 927 per day during the first half of 2005. The most frequently targeted industry was education, followed by small business and financial services.

- The time between the disclosure of a vulnerability and the release of associ-

ated exploit code decreased from 6.4 days to 6.0 days. In addition, an average of 54 days elapsed between the appearance of a vulnerability and the release of an associated patch by the affected vendor.

This means that, on average, 48 days elapsed between the release of an exploit and the release of an associated patch; during this time, systems are either vulnerable or administrators are forced to create their own protections.

- During the first half of 2005, Symantec documented 1,862 new vulnerabilities—the highest number ever recorded. Ninety-seven percent of these vulnerabilities were classified as moderate or high in severity, and 59 percent of all vulnerabilities were found in Web application technologies, marking an increase of 109 percent over the first six months of 2004.

- A growing number of so-called "Win32 viruses" and worm variants were also reported during the first half of 2005. Symantec documented 10,866 new Win32 virus and worm variants, an increase of 48 percent over the previous reporting period and 142 percent over the first half of 2004.

A common concern among Internet security experts is that some of the largest software companies may

inadvertently help hackers by managing their new software releases poorly.

In March 2005, it was widely reported that Microsoft Corp. was giving early versions of its software security patches to select U.S. government agencies and other organizations.

This early distribution worries some experts because it could give hackers critical details about how to break into unprotected computers. Put simply, if a hackers can see an unreleased version of a security upgrade, he can see what problems the software company is trying to solve—and then exploit those problems before the fixes are circulated widely.

Microsoft spokespeople insisted that participants in its security-testing programs follow strict rules to protect the software patches from leaking onto the Internet. But the fact that the company was admitting to the early testing was enough to bother the Internet security community.

Peiter Zatko (a famed computer security expert who goes by the handle "Mudge") said the admission was "the worst possible thing for national security.... What Microsoft is doing is really, really bad."

Why? Because, an unpublished security upgrade is like a treasure map for hackers—it tells them where the weak points are in most computers.

> These so-called "zero-day threats" target vulnerabilities before they're publicly announced and patches or other fixes are posted. For these reasons, they are the most dangerous risks.

In December 2004, one of three men who hacked into the national computer system of Lowe's hardware stores and tried to steal customer credit card information was sentenced to nine years in federal prison. Government prosecutors said it is the longest prison term ever handed down in a computer crime case in the United States.

Brian Salcedo of Whitmore Lake, Michigan, had pleaded guilty several months earlier to conspiracy and other hacking charges.

> Salcedo had been accursed of "wardriving"—a practice by which hackers move around a city or neighborhood with an antenna, searching for vulnerable wireless Internet connections.

Salcedo and his accomplices tapped into the wireless network of a Lowe's store in suburban Detroit. They used that connection to enter the chain's central computer system in North Carolina and installed a program to capture credit card information. (Lowe's officials said the men did not obtain any such information.)

ZOMBIES AND BOTS

There are hundreds of viruses, Trojans and worms that can hijack a computer for use as a bot or zombie in a spam-forwarding army. Most are designed to fool a lazy computer user into opening his computer to them.

For example: In late 2004, the Zafi.D worm—which posed as a "Happy Holidays" e-mail—spread around the Internet quickly. The typical message read:

> *Sender: Pamela M.*
>
> *Subject: Merry Christmas!*
>
> *Happy HollyDays! Click on this link for your Postcard! :)*

Zafi had been around for months, though it had appeared in Eastern European languages only at first. At some point during the Fall of 2004, more ambitious crooks had gotten hold of the worm, modified it for English and made it available on several Web sites that served the hacker underground.

Zafi spread by scanning the infected computer for e-mail addresses and sending copies of itself to every address it found. Most importantly: The worm enabled hackers to gain remote control of the infected computer. To this end, it would disable and delete firewalls and antivirus software.

But users had to double-click on the Happy Holidays attachment in order to become infected. To

get people to click, different hackers used different attachment names—but some variation of the word *postcard* always appeared in the file name.

HACKER "CRED"

During the summer of 2005, a banking security software firm hired Kevin Mitnick, the master hacker (and one-time top of the FBI's "Most Wanted" cybercriminal list) turned computer security expert to test its network security programming.

41st Parameter Corp.'s antifraud technology—called *TimeDiff Linking*—was designed to protect banks against phishing scams and resulting consumer security problems, online identity theft and fraud.

> The software company was one the rise, with some good response to its products. But company managers knew banks wouldn't simply take their word for it. They hired Mitnick to test their technology by attempting to foil the system and mount a phishing attack. They knew his name still meant a lot in some high-tech circles.

Mitnick attempted to hack through TimeDiff Linking protection by using a method called sequel injection in hopes of discovering a mistake in the application coding that would allow him to change the logic and bypass security.

Apparently, it didn't work.

According to Mitnick:

> *Given enough time, effort, and resources, any system can be broken, but the effort to break this technology is too time consuming. ...The biggest security breach I find in software is due to human nature. Humans make mistakes as they rush products to market. Sometimes companies don't hire experienced programmers. No one is immune to hacking....*

NO PLACE IS COMPLETELY SAFE

According to Martha Stansell-Gamm, the chief of the Computer Crime and Intellectual Property Section at the Department of Justice:

> *...The hacker phenomenon keeps raising in my mind the question of whether or not hackers are a problem, or a symptom of an intrinsic problem in this whole new technology. ...It's important to understand that networks, like streets, like automobiles, are never going to be perfectly secure.*

She said there were a lot of reasons that hackers survive. These reasons included:

1) The crimes are not always or even frequently detected. That's a harder technological problem than it seems.

2) The people who are working on system security have a tendency, because it's their discipline, to view hackers as a technological problem with technological solutions. They don't naturally think about turning to other specialists like

law enforcement to assist them in securing their system.

3) There's no doubt that some victims are concerned about competitive disadvantage if a certain incident becomes known.

Stansell-Gramm concluded that "to the extent that our software is vetted and perfect and bug-free, somebody is going to be paying for that. Is the public willing to pay to buy more expensive software?"

Most computer experts agree that the answer to that question is *No*. So, hacking exploits will continue.

BIG-TIME HACKING

In October 2005, Dutch authorities arrested three people on charges of running one of a hacker botnet comprising over 100,000 zombie PCs.

The three men—aged 19, 22 and 27—were not named. Police confiscated computers, cash and a sports car during searches of the suspects' homes.

With over 100,000 infected systems, the network is one of the largest ever detected, prosecutors claimed. The suspects were charged with computer hacking, destroying automated networks and installing adware and spyware. The trio used the W32.toxbot Internet worm to recruit systems for their botnet. The worm had first been detected in early 2005 and infected systems all over the world.

The suspects in the Dutch case kept changing their malware to avoid detection.

The men also allegedly built worms with keystroke logging software to gather login names to commit credit card fraud and identity theft.

Arkansas-based Acxiom Corp. is one of the largest information brokers in the United States. The company has extensive online (and off-line) security systems for protecting its data files. But even this kind of privacy- and secrecy-prone company can get hacked.

For Acxoim, the big hack came in 2003. According to Acxiom Chief Privacy Officer Jennifer Barrett:

> *The hackers were employees of an Acxiom client and that client's contractor. As users with legitimate access to the server, the hackers had received authority to transfer and receive their own files. The hackers did not penetrate the firewalls to Acxiom's main system. They did, however, exceed their authority when they accessed an encrypted password file on the server and successfully unencrypted about 10 percent of the passwords, which allowed them to gain access to other client files on the server.*

Who were these hackers?

Scott Levine, who effectively controlled Snipermail.com, Inc., was indicted by a federal grand jury for conspiracy, unauthorized access of a protected computer, access device fraud, money laundering and obstruction of justice. The 45-year-old Levine, who operated out of Boca Raton, Florida, was no script-kiddie. He was a dedicated white-collar criminal.

Snipermail distributed advertisements—essentially, spam—via the Internet to e-mail addresses on behalf of advertisers or their brokers.

In the spring of 2005, federal prosecutors filed charges of illegal intrusion by Levine and other Snipermail employees into a computer database owned and operated by Acxiom.

The case stretched back almost two years. In July 2003, investigators with the Sheriff's Office in Hamilton County, Ohio, discovered (in the course of an unrelated investigation) that an Ohio resident named Daniel Baas had illegally entered into an Acxiom file transfer protocol (FTP) server and downloaded significant amounts of data.

During the course of *that* investigation, and in follow up internal investigations conducted by Acxiom, investigators discovered a second set of intrusions into Acxiom. Those intrusions came from a different Internet protocol address—and formed the basis of the indictment of Scott Levine.

Federal investigators discovered that Snipermail employees had built on Baas' foundation and obtained access to other databases on the ftp.acxiom.com server. Soon, the Snipermail employees started downloading large data files from that server...and continued for many months.

It was rich hunting while it lasted.

CHAPTER

11

PHISHING

If you're like most people who use the Internet and try to keep abreast of the news, you know that phishing is one of the fastest-growing on-line crimes. But you may not know exactly what the term means. So, in short, here's how phishing works:

You have a bank account and you've been using its on-line banking feature for a couple of years—to check your balance, make transfers and pay bills. It's always worked pretty well. One morning, you get an e-mail that says it's from your bank; the e-mail warns you about a rash of recent identity theft scams. It asks you to log in and verify your account information. And it uses urgent language like "Your immediate attention is required."

The e-mail looks authentic. You click on the hypertext link in the e-mail and go to a page that's in the same style as your bank's Web site.

You fill in your name, address, account number, Social Security number, your password (or your mother's maiden name) and phone contacts. After you submit the information, a thank-you message

appears that says the information all checks out and your account is secure. It even gives you a transaction number for future reference.

A few days later, you use your debit card at the grocery store—and it's declined for a $20 purchase. That's strange. You have a couple thousand dollars in that account. The grocery clerk shrugs and says it happens a lot; the system could be acting up.

You rush home and call your bank. Your account is overdrawn. In fact, several big checks have bounced in the last few days.

The e-mail about confirming your account information was a fake. It wasn't from your bank.

You entered your information into a database run by crooks (who may be operating in your town...or in Russia). Nothing was confirmed. The transaction number you got after you entered your information was randomly-generated gibberish.

The fake e-mail and Web site were the tools of phishing. That term applies to the theft of personal information by misleading unsuspecting people.

As soon as the crooks got your banking information, they put it together with dozens of other "profiles" and sold them in a black market exchange of stolen IDs. Your information may have changed hands several times in a couple of days, selling for anywhere from $50 to $500.

Finally, someone got hold of your information with the intent of using it. He (and these crooks are predominantly men) checked the balance in your account and withdrew cash. He could do this in several ways—log onto your bank's Web site and transfer the funds out, make an electronic draft or create a debit card that allowed him to withdraw cash from a bank machine.

Then, he wrote a number of checks that he suspected would bounce. He could print these on paper or generate them electronically. He could purchase goods with the bad checks...or cash them at other banks or check-cashing agencies.

Some thieves try to make purchases on-line, having goods delivered to a drop and then selling them through on-line auctions.

> In most cases, you're not liable—legally—for the trouble these crooks have made. But you're going to have to do a lot of work to prove to your bank and others that you're not. And your credit rating will suffer in the process.

A HISTORY OF PHISHING

Phishing first started happening in noticeable volume in the early 2000s. Phishing scams were originally launched by hackers who wanted little more than wicked stories and bragging rights in Internet chat rooms and on Web sites.

According to the FBI's Internet Crime Complaint Center (IC3), things took a turn for the worse when organized crime groups in the U.S. and Eastern Europe saw the profit potential in the scams. Poorly-done phishing e-mails—with misspellings and strange English usage—were replaced by smoother pitches.

> **The biggest increase in incidents happened in the Spring of 2004, when the number of personal data thefts reported to law enforcement and financial institutions increased more than 200 percent a month for several months.**

Most Internet security experts agree that phishers have moved their attention to large-scale identity theft from corporate databases. (If nothing else, this information can be used for generating targeted phishing schemes.)

Still, phishing is a growing problem. Detailed statistics are hard to establish, since the crime is relatively new and generally underreported. But:

- Gartner (a Connecticut-based Internet commerce research firm) estimated that phishing scammers took consumers and their banks for about $929 million in the year ending May 2005.

- According to the Anti-Phishing Working Group (an Internet trade organization), nearly five percent of recipients

respond to phishing—a much larger rate than those who respond to ordinary spam and other solicitations.

• The Anti-Phishing Working Group estimates that between 75 and 150 million phishing e-mails are sent every day.

According to the Anti-Phishing Working Group:

> *Phishing attacks use both social engineering and technical subterfuge to steal consumers' personal identity data and financial account credentials. ...Hijacking brand names of banks, e-retailers and credit card companies, phishers often convince recipients to respond.*

Phishing e-mails don't always claim to come from banks or credit card companies. Common variations of "fronts" claim to be from the on-line cash-transfer service PayPal or the popular Internet auction site eBay; more recent variations claim to be from auto-finance companies and insurance companies.

According to the consumer-protection clearinghouse FraudWatch International, these are the five companies most often used as fronts by phishers trying to steal personal information:

Company	complaints (2003-2005)
eBay	1,956
Washington Mutual	1,104
PayPal	896
SunTrust Bank	611
Citibank	588

PHISHING E-MAIL EXAMPLE

Here's one example of a phishing e-mail that made the rounds among North American computer users in 2004 and 2005:

Dear U.S. Bank account holder,

We recently reviewed your account, and suspect that your U.S. Bank Internet Banking account may have been accessed by an unauthorized third party. Protecting the security of your account and of the U.S. Bank network is our primary concern. Therefore, as a preventative measure, we have temporarily limited access to sensitive account features.

To restore your account access, please take the following steps to ensure that your account has not been compromised:

1. Log in to your U.S. Bank Internet Banking account. In case you are not enrolled for Internet Banking, you will have to use your Social Security Number as both your Personal ID and Password. For security you can provide your information in the box bellow.

2. Review your recent account history for any unauthorized withdrawals or deposits, and check your account profile to make sure not changes have been made. If any unauthorized activity has taken place on your account, report this to U.S. Bank staff immediately.

To get started, please click the link below:

https://www4.usbank.com/internetBanking/ RequestRouter?requestCmdId=DisplayLoginPage

We apologize for any inconvenience this may cause, and appreciate your assistance in helping us maintain the integrity of the entire U.S. Bank system. Thank you for your prompt attention to this matter.

Sincerely,

The U.S. Bank Team

The site mentioned in the e-mail was a fake; it had nothing to do with U.S. Bank. Anyone who did as the e-mail instructed ended up giving his banking details to a gang of sophisticated identity thieves. They sold and resold this data several times within 72 hours of stealing it.

> **A successful phishing operation might bring in thousands of account numbers each month, along with identifying details: names, addresses, phone numbers, passwords, PINs and Social Security numbers.**

A FAVORITE FRONT: EBAY

In 2003, a major phishing scam occurred in which users received e-mails supposedly from eBay claiming that the user's account was about to be suspended unless they clicked on the provided link and updated their credit card information.

The scam counted on people being tricked into thinking they were actually being contacted by eBay and that they going to eBay's site to update their account information. By spamming large groups of people, the phisher counted on the e-mail being

read by at least a few people who actually had listed credit card numbers with eBay legitimately.

ANYONE CAN BE A VICTIM

Phishing is a risk to almost any consumer. But, perhaps more importantly, it's a risk to the overall stability of and consumer trust in the Internet.

> Internet businesses fear that, if phishing scams continue and more people get burned, consumers will shop off-line and send legitimate business-related e-mail straight to the delete folder.

To shore up this trust, in March 2005, Microsoft Corp. announced that it was filing 117 lawsuits against unknown Internet site operators that it claimed were engaged in phishing schemes.

Microsoft said it was filing so-called "John Doe defendant" lawsuits in U.S. District Court in Seattle in an attempt to establish connections between worldwide phishers and discover the largest-volume operators. Company spokespeople admitted that Microsoft hoped to learn the identities of crooks behind a rash of fraudulent e-mail messages during late 2004 and early 2005 that specifically targeted customers of its MSN Internet and Hotmail e-mail services.

Every Web site and e-mail contains a unique Internet address that can be traced back to the service that hosts it. Once a federal judge gave consent for the

lawsuits to go forward, Microsoft could subpoena the Internet service providers from which the phishing scams originated in an attempt to force the ISPs to reveal the identities of the account holders.

In many on-line fraud cases, the perpetrators thread their traffic through multiple computers and across several ISPs. Investigators can only follow the trail by learning who paid for the Internet services at each link in the chain.

Microsoft had used the John Doe strategy successfully before. In October 2003, it filed a similar lawsuit after a phishing scam targeted MSN customers. Six months and two subpoenas later, the company tracked the scam back to 21-year-old Jayson Harris of Iowa.

Harris had used his grandfather's MSN account to send out phishing e-mails—and had directed his Web site and e-mail traffic through four different ISPs on three continents.

PHISHING IS LIKE VIRUSES

Many of the same security measures that protect against viruses can shield you from phishers.

In 2004, one phishing scam went live as soon as a consumer opened a malicious e-mail in an older version of Microsoft Outlook. When the message (often just a blank page) was viewed, the victim computer's host file was altered by a bit of code in

the e-mail. The next time the consumer attempted to log on to her bank's Web site, she was redirected to a bogus Web site.

Few, if any, of the victims even realized they were doing business with a server somewhere in Russia. The scam targeted customers of several financial institutions in Brazil and was soon followed by a similar attack against British banking customers.

In some cases, the crooks use their stolen information to hack into corporate computer networks. If a phisher knows that Jane Smith logs in as Jsmith13 and uses the password "supergirl" at eBay, he'll surf on-line postings and databases to find out where Ms. Smith works. People often use the same password for many on-line accounts. So, if Jane Smith works at Company X, the phisher will go to that company's site and try logging on as Smith.

This works often enough that some crooks use phishing as tool for hacking corporate systems.

A number of big Internet service providers—including EarthLink and Comcast—spell out in customer correspondence and on their sites what information their technical support or accounting representatives may request. And they specify the channels through which such requests will be made.

For example, EarthLink representatives may ask users for the last four digits of their Social Security numbers over the telephone—but never by e-mail.

"E-MAIL CALLER ID"

Computer security experts generally blame people-not programs-for most of the biggest phishing scams. There's a common saying among these experts: "You can't upgrade common sense; and you can't install intelligence." But these cynical experts seem to agree that one solution to phishing would be a global authentication standard that verifies whether an e-mail has indeed been sent from its stated domain.

> "E-mail caller ID" could be combined with authentication tools that integrate with Web browsers and alert users when they land on a spoofed Web site.

How would this work? A trusted sender certificate in the S/MIME file format—which is supported by most e-mail programs—would help to assure recipients that the e-mail they receive is legitimate and validated by an independent certificate authority (though smart phishers are likely to find a way to hack the S/MIME certificate mechanism, just as they've managed to get around other security certificates and the once-sacred padlock icon).

ONE BIG BUST

In October 2004, the Justice Department and the Secret Service announced the completion of Operation Firewall—an international arrest of 28 people in eight states and several countries, including Sweden, Britain, Poland, Belarus and Bulgaria.

Among those arrested were Andrew Mantovani of Arizona, David Appleyard of New Jersey and Russian national Anatoly Tyukanov. The Feds said the three were leaders of Shadowcrew.com, the largest English-language Internet black market group—trading in everything from stolen credit cards and bank account numbers to counterfeit drivers' licenses, passports and Social Security numbers.

> But, less than a year later, most of the Shadowcrew traders had reemerged, adapted and resumed business. Some security experts complained that Operation Firewall only caused the players in the black-market economy to become more sophisticated.

COMMON TRICKS PHISHERS USE

Phishers use various tricks to convince victims to respond—including enticing subject lines, forging the address of the sender, using genuine looking images and text and disguising the links within the e-mail. Among the most common tricks:

- Phishing e-mails tend to have subject lines that appear to be related to the supposed source—to entice the user to open the e-mail. For example, a subject line might read: "Important notice for all Internet Banking Users."

- A common trick involves setting up domains such as "paypaI.com" (the lowercase *l* is actually an uppercase *I*.)

- It's also common for subject lines to replace characters with numerals or other letters, to bypass spam filters (again, like the uppercase *I* for lowercase *l* trick). Some phishing e-mails will deliberately misspell key words to bypass spam filters.

- The forging of the sender address is an easy deception method. A phishing e-mail will often have a forged sender address matching the front company.

- Some phishing e-mails also have genuine links to the front company's privacy policy and other pages on the legitimate Web site.

- Links within an e-mail are deliberately disguised in another attempt to deceive the recipient. The e-mail may display a genuine front company URL but, when that hypertext link is clicked, it will take the user to a different Web site.

BANKS, BROKERAGES RESPOND

Banks and brokerages know that they are the most frequent fronts used by phishers and other on-line crooks. Legitimate financial institutions have to balance their interests in educating customers about the risk with the risk of frightening people away from on-line banking.

Here's one example of how a major Internet-based stock brokerage broached the subject:

Dear NAME,

Account Number: XXXX-XXXX

*At E*TRADE FINANCIAL, we are commit-*
ted to helping you protect yourself against on-line
fraud. We already maintain the highest levels of
security available, including 128-bit encryption
*on our Web site and our new E*TRADE Com-*
plete Digital Security ID.

In addition, there are a few things you should
know about "phishing", one of the fastest grow-
ing forms of fraud today.

*E*TRADE FINANCIAL, visit our Online Se-*
curity Center. You may also forward the e-mail
with attachments to onlinesecurity@etrade.com.

DON'T GET HOOKED

Here are some additional tips to avoid taking the
bait on a phishing attempt:

- Be suspicious of any e-mail with an ur-
 gent request for personal financial in-
 formation.

- Don't open attachments or click links
 in unfamiliar e-mails, as they may place
 programs known as "keystroke loggers"
 on your computer.

- Avoid filling out forms contained in e-
 mail messages or in pop-ups that ap-
 pear over a legitimate company's Web
 site.

A report from Symantec released in September 2005 concluded that one out of every 125 e-mail messages scanned by its Brightmail AntiSpam system was a phishing attempt. This was an increase of 100 percent from the year before.

Phishers automatically run thousands of e-mail addresses through Web site registration and password-reminder tools. Because many online businesses return a specific message when an e-mail address is registered with the site, crooks can find out whether that address represents a valid customer.

This "hostile profiling" is only one way phishing messages are getting more targeted. By matching e-mail addresses with Web sites, crooks can uncover the gender, sexual preference, political orientation, geographic location and hobbies of the person behind an e-mail address.

How does hostile profiling work?

- A crook obtains a list of e-mail addresses. He can buy a list, collect addresses from the Internet using harvesting tools or use other means.

- The crook writes or buys a program to run the e-mail addresses against the registration and password-reminder features of popular Web sites.

- Responses let the crook know whether an address is registered with the site. The data is used to compile profiles.

- Profiles are used to target spam and phishing e-mails.

As a result, attacks could have a higher success rate, because the e-mail presents unsuspecting recipients with accurate information in a message that looks like legitimate correspondence.

For example, an e-mail purporting to come from a bank or credit card company could name the victim and refer to an online store that she really uses.

One ingenious phishing tactic replaces the address bar at the top of a Web browser with a fake one. This technique allows the phisher to display a completely fraudulent Web address, while taking the consumer to a fake site. The fraudulent site detects the user's browser and runs custom code that removes the real address bar and replaces it with a fake bar at the top of the window.

> **This type of attack—used along with an e-mail asking to update your personal information—is an effective way for a crook to increase the volume and quality of personal information acquired.**

MORE TIPS

The Federal Trade Commission suggests that e-mailing financial and personal details is never a good idea—and legitimate companies don't request those details in an e-mail.

The FTC suggests these tips to help you avoid getting hooked by a phishing scam:

- Resist the urge to respond to e-mail that claims your account has been frozen or is suspected of fraud use. Legitimate institutions will contact customers by phone or postal mail.

- If you are concerned about your account, contact the institution using a telephone number you know is genuine or open a new Internet browser session and type in the company's Web address yourself.

- Use your phone to check out contacts. Many phishing attempts originate from outside the U.S. and aren't likely to have working domestic phone numbers.

- Keep your browser and/or operating system software updated with legitimate upgrades or patches.

- Use anti-virus software and a firewall— and keep them up to date.

- Don't e-mail personal or financial information. E-mail is not a secure method of transmitting personal information.

- Never provide your password over the phone or in response to an unsolicited Internet request. A financial institution will never ask you to verify your account information online.

- If you initiate a transaction and want to provide personal or financial information through an organization's Web

site, look for indicators that the site is secure, like a lock icon on the browser's status bar or a URL that begins "https:" (the "s" stands for "secure"). Unfortunately, no indicator is foolproof; some phishers have forged security icons.

- Forward spam that is phishing for information to spam@uce.gov and to the company, bank or organization impersonated in the phishing e-mail.

Finally, it's worth repeating that you should keep your anti-virus and firewall software updated. Keeping these programs up-to-date takes a little time; but it's worth the effort.

Anti-virus software scans incoming communications for troublesome files. Look for anti-virus software that recognizes current viruses as well as older ones; that can effectively reverse the damage; and that updates automatically.

A firewall helps make you invisible on the Internet and blocks all communications from unauthorized sources. It's especially important to run a firewall if you have a broadband (permanent) connection.

12

SPOOFING

Throughout history, crooks have masked their true identities. When the issue is Internet fraud, the preferred mask is a bag of technology tricks that, taken together, are known as "spoofing."

> **Spoofing is the act of sending an e-mail, instant message or other Internet communication in someone else's name. It's a form of identity theft; it's also a tool for phishing and other tactics for continuing and expanding identity theft.**

The first and more common type of spoofing focuses on faking a sender's e-mail address.

E-mail spoofing takes various forms; but it always aims for the same result—an unwitting target receives an e-mail that appears to be from one source when it actually was sent from another.

Who do crooks pretend to be? Anyone who the target would be likely to trust. This might include e-mails claiming to be from:

- system administrators asking users to change their passwords;

- supervisors or upper-level management setting new network policy;

- clients or customers threatening to move their business if a corporate account isn't changed immediately;

- customer service reps from financial institutions asking users to confirm their account information.

It's easy to spoof e-mail. One reason: Simple Mail Transfer Protocol (SMTP), the most common method for sending e-mail, lacks authentication. If a site has configured its mail server to allow connections to its SMTP port, anyone can connect to that port and—with a few simple commands—send e-mail that appears to be from that site.

> **And there are other ways to spoof e-mail. For example: A crook can modify his own Web browser interface to create a sender address that looks something like the address of a trusted company.**

WEAK SPOOFING AND STRONG

Computer security experts consider tricks like using authentic e-mail domains that *look* similar to a trusted company's domain "social engineering."

In hacking circles, these simple e-mail manipulations are called "weak spoofs." In most cases, the

SMTP header (the several lines of code that comes at the top) on an e-mail spoofed in this way will show that the message comes from a different origin. But most people don't look at SMTP headers and will assume an e-mail comes from the first name they see in the "sender" line.

The second—and more complex—type of spoofing focuses on the manipulating the Internet Protocol (IP) address from which the crooked e-mail is sent.

> In IP spoofing, a crook gains unauthorized access to a computer or a network by making it appear that a malicious message has come from a trusted source. Once inside the network, the crook uses that system as the source of his e-mail.

Hackers call this type of manipulation "strong spoofing" or "real spoofing."

If someone logs on to your computer remotely and sends e-mails from it, there's no way for other people to tell that the crook is really the crook...and not you. But, if you find out this is happening, you should be able to find the crook's original location in your machine's IP or firewall software logs.

> Either e-mail or IP spoofing can be an element of a phishing scam; but spoofing also has other uses for crooks that go beyond phishing.

A HISTORY OF SPOOFING

IP spoofing was known about and discussed from the earliest days of the Internet—when it was still used primarily by universities and government agencies. In 1985, former National Security Agency computer expert Robert Morris published the academic paper *A Weakness in the 4.2BSD Unix TCP/IP Software*, which laid out the basic mechanics of how a hacker could exploit weaknesses in the software that ran the Internet. A few years later, Stephen Bellovin of AT&T Laboratories discussed the problem more in *Security Problems in the TCP/IP Protocol Suite*, one of the first papers that dealt with Internet security issues in a comprehensive way.

To make a complicated matter simple, e-mail and Internet pages deliver information in groups of data called "packets" (these are also called "datagrams," "frames" and other things, depending on the specific application and the person talking).

Each packet has several parts, the most important of which are the header and the data itself. The header is the part of the packet that tells routers (also called "Internet hosts") where the data came from and where it's being sent. The header is the part of a packet that a crook needs to alter to spoof an online identity.

The academic papers from Morris and Bellovin gave an alert crook all he would need to run an IP spoof. One of the first alert crooks to use these tools was

the hacker and—later—convicted felon Kevin Mitnick. On Christmas Day 1994, Mitnick used spoofing techniques to hack into the computer of Tsutomu Shimomura (a well-known computer security expert at the San Diego Supercomputer Center) and steal cutting-edge security programs.

Since those early days of spoofing, many of the things that Mitnick and others did "by hand" have been automated in standard spoofing software programs that allow crooks to fake their e-mail and IP addresses without having to do so much work.

THE MECHANICS OF IP SPOOFING

So, IP spoofing involves altered packets and the TCP/IP suite. But what does "the TCP/IP suite" mean?

It's a combination of two kinds of communication software used to connect a computer to the Internet.

Internet protocol (IP) is a connectionless model for exchanging data between computers. "Connectionless" means no information is exchanged regarding transaction state (the system used to route packets on a network) and there's no way to ensure that a packet is properly delivered to its destination.

If you look at an IP header, you'll see five rows of information: the top three rows contain various pieces of information about the data in the packet; the next two rows contain the source and destination IP addresses.

A crook trying to spoof an IP address focuses on those two rows. Using one of several editing tools,

he can modify these addresses—specifically the "source address" field. That's relatively easy.

Transmission Control Protocol (TCP) uses a connection-oriented design. What does this mean? TCP is the more reliable transport protocol in the TCP/IP suite; it's often described as a "layer" of software that fits over—and makes sense of—the less organized IP data exchange.

A TCP header is different from an IP header. But TCP headers can be altered, too. They're just more difficult to manipulate.

Every byte of data exchanged across a TCP connection is sequenced. Each TCP packet header contains a sequence number field and acknowledgment number field, which includes the value of next expected sequence number and acknowledges all data up through that number minus one.

This relationship confirms, on both ends, that the proper packets are received.

Back in the old days, the hardest part of a spoofing attack was predicting the right sequence number. This was made even more difficult by the fact that the attack was "blind." The crook would take over the identity of a trusted host in order to subvert the security of the target. Packets sent with a forged IP address reach the target fine but packets the target sends back (meant for the trusted host) end up lost. The crook never sees them.

So the crook had to know what was sent—and know what response the target expects. Until he'd hacked in, the crook couldn't *see* what the target host sent; but, if he was smart, he could *predict* what it sent. If his prediction was right, the target computer would treat him as a trusted host.

In the 1990s and 2000s, hackers wrote programs that automated a lot of the guessing that went into blind attacks. The process no longer requires such deep knowledge and strong instincts.

Hackers also developed alternatives to blind spoofing. These include:

- Non-blind spoofing. This attack takes place when the crook is on the same local network as the target and can "see" the sequence and acknowledgment of packets. The threat of this type of spoofing is session hijacking and an attacker could bypass any authentication measures taken place to build the connection.

- Man in the Middle Attack. This is also called *connection hijacking*. In this attack, the crook intercepts a legitimate communication between two mail servers to control the flow of communication and to eliminate or alter the information sent by one of the original participants without its knowledge. In this

way, an attacker can fool a target into disclosing confidential information by spoofing the identity of the original sender or receiver.

• Denial of Service Attack. IP spoofing is almost always used in denial of service attacks (DoS), in which attackers are concerned with consuming bandwidth and resources by flooding the target with as many packets as possible in a short amount of time. When multiple compromised servers are participating in the attack, it's effectively impossible to block the traffic.

A common misconception is that IP spoofing can be used to hide a crook's IP address while surfing the Internet, chatting on-line, sending e-mail, etc. This is generally not true.

USES OF "SOCIAL ENGINEERING"

Some spoofed Web sites have registered a domain name similar to that of the organization they are appearing to be from. For example, one phishing scam targeting Barclays Bank used the domain name http://www.barclayze.co.uk.

Other examples include using a sub-domain such as http://www.barclays.validation.co.uk, where the actual domain is validation.co.uk—which is not related to Barclays Bank.

Other social engineering spoofs include:

- *URL Spoofing of Address Bar* involves replacing an Internet browser's address bar with a fake bar using images and text. The user *thinks* he's at one site but is actually at another.

- *Hovering Text Box over Address Bar* involves the placement of a text object with a white background over the URL in the address bar. The text object contains a fake URL, which covers the genuine URL.

- *Two Pages Displayed (Pop Up Windows)* involves the use of script to open a genuine Web page in the background while a bare pop up window (without address bar, tool bars, status bar and scroll bar) is opened in the foreground to display the fake Web page, in an attempt to mislead the user to think it is directly associated to the genuine page.

NEW PROBLEMS ALL THE TIME

In February 2005, several Internet security experts noted that a browser feature meant to permit Web addresses in Chinese, Arabic and other languages could encourage online crooks by making scam Web sites look legitimate to visitors.

Officially, the Internet's Domain Name System supports only 37 characters—the 26 letters, 10 numerals and a hyphen. But, in response to a growing

Internet population worldwide, engineers have been working on ways to trick the system into understanding symbols from other languages.

Engineers have rallied around a character system called Unicode. The newly discovered exploit takes advantage of the fact that characters that look alike can have two separate codes in Unicode and thus appear to the computer as different. For example, Unicode for "a" is 97 in the Latin alphabet, but 1072 in Cyrillic.

Subbing one for the other can allow a scammer to register a domain name that looks to the human eye like "paypal.com," tricking users into giving passwords and other sensitive information at what looks like a legitimate site.

Here, again, a good solution is to type Web addresses directly into a browser—rather than clicking on a link sent via e-mail or even copying and pasting that link.

WIRELESS CONNECTIONS

In February 2005, researchers at the annual meeting of the American Association for the Advancement of Science outlined new breeds of "stealth attacks" and proposed measures to defeat them.

The attacks take advantage of the "ad hoc" nature of wireless networks you might casually log into at an Internet cafe or airport. In such networks, there

is no hard-wired infrastructure for connecting computers with each other. Instead, the computers have to organize themselves into networks.

Crooks can insert themselves into ad-hoc wireless networks by manipulating Internet protocols to make their link in the communication chain seem particularly attractive.

> This is essentially a "man-in-the-middle" attack—in which the crook eavesdrops on network traffic, then passes the data along to the rightful recipients without leaving a trace.

A sophisticated crook can spoof an online banking site to collect passwords and other personalization.

Another type of threat would involve overwhelming wireless data traffic with denial-of-service attacks, already well-known in the wired environment.

> A wireless network is particularly vulnerable to denial-of-service attacks because some of the machines in the network could be low-capacity devices such as personal digital assistants.

SPOOFING E-MAIL

As we've noted before, e-mail is an extremely insecure protocol, susceptible to the spoofing of

anybody's e-mail address by anybody. Spoofing the from address is a common tactic of spammers and is beginning to be used by e-mail viruses to obscure their source as they spread.

The receiving mail server should issue a DNS request following the "MAIL FROM:" to verify that the IP address connected to it is a valid outgoing mail server for the domain of the "MAIL FROM:" address.

The receiving mail server may also parse the headers of the message and verify that the domain in the FROM: address lists the IP address of the sending mail server as a valid outgoing mail server.

One example: Yahoo.com is a favorite return address of spammers. If Yahoo.com places the needed DNS entries and your mail server screens for them, no one can pretend to send e-mail from Yahoo.com.

HELP—FROM BILL GATES

In the summer of 2005, Microsoft was promoting a tool for combating spoofing called *Sender ID*.

Sender ID was an e-mail-authentication technology that verified the domain name from which mail was sent. It validated the origin of an e-mail by verifying the IP address of the sender against the purported owner of the sending domain.

> It was a fairly straightforward approach and, while
> it didn't prevent scams from being initiated, it did
> make them easier to detect because it provided a
> more reliable answer to the question "Who actually
> sent this message?"

Sender ID became the subject of much scorn when
it was discovered that, at the same time the com-
pany was promoting Sender ID as a global stan-
dard, Microsoft was trying to patent the technol-
ogy surrounding Sender ID.

Numerous major service providers participating in
the Messaging Anti-Abuse Working Group, an in-
dustry consortium promoting the development of
new e-mail authentication standards, continued to
test Sender ID. Their early findings were not good
news for Microsoft.

According to the technical committee's white pa-
per, programs like Sender ID

> *are comparable to a automobile license plate is-*
> *sued by a foreign country: they show that the ve-*
> *hicle is permitted to drive in that country, but*
> *make no indication as to whether that country's*
> *regulations are similar to yours—and we can only*
> *assume that the driver inside is permitted to use*
> *that vehicle.*

But the committee went on to explain that, along
with these slight benefits, there were some signifi-
cant downsides to implementing Sender ID.

Those downsides included:

- forwarded or re-sent mail would fail authentication unless e-mail systems rewrote return addresses and added new headers;

- sites publishing authentication records would have to ensure that their records permitted e-mail from all possible points of origination or risk having legitimate e-mail mislabeled as spam;

- the programs would not provide protection against forgery of the most common user-visible mail headers;

- some checks in accordance with Sender ID might yield inaccurate authentication, due to misinterpretation of the Sender's authorization.

As a result, several major service providers removed their Sender ID and SPF statements from their DNS records in order to avoid potential confusion and lost e-mail.

But, just as the industry was backing away from Sender ID, Microsoft unilaterally declared that all e-mail sent to MSN and Hotmail would be scanned for Sender ID compliance.

If your e-mail doesn't pass a patent-pending Sender ID check, it might be labeled as spam and consigned to the Spam folder.

PRACTICAL TIPS

Microsoft's Sender ID may be best hope for battling spoofing; or it may be another example of the giant company's heavy-handed marketing tactics.

While experts hash out the answer, there are basic steps that most ordinary computer users can take to reduce the risk that they'll be spoofed:

- Use cryptographic signatures (PGP "Pretty Good Privacy" or other encryption) to exchange authenticated e-mail messages. Authenticated e-mail provides a mechanism for ensuring that messages are from whom they appear to be, as well as ensuring that the message has not been altered in transit.

- Configure your e-mail delivery software to prevent someone from directly connecting to your SMTP port to send spoofed e-mail to other sites.

- Ensure that your e-mail delivery software allows logging and is configured to provide sufficient logging to assist you in tracking the origin of spoofed e-mail.

- Consider a single point of entry for e-mail to your site. You can implement this by configuring your firewall so that SMTP connections from outside your firewall must go through a central mail hub. This may assist in detecting the origin of spoofing attempts to your site.

- Educate yourself about the e-mail policies and procedures of any sites you use in order to lower your risk of being "social engineered" or tricked into disclosing sensitive information (such as passwords).

13

SPAM

Spam is a tool of scammers worldwide. Also called *junk e-mail* or *unsolicited bulk e-mail* (UBE), spam grows at an alarming rate. It accounted for 42 percent of all Internet e-mail traffic in January 2003; it made up 65 percent of traffic in June of 2004.

In the early days of the Internet, spam was dominated by pornography; but, in the mid 2000s, a junk e-mail is far more likely to offer a get-rich-quick scheme or a miracle drug.

According to a 2004 study by the British computer security firm Clearswift Ltd., spam content broke down along the following categories:

- Finance (39.0 percent)
- Healthcare (30.6 percent)
- Other (15.0 percent)
- Direct Products (9.6 percent)
- Pornography (4.8 percent)

The Clearswift study estimated that spammers have around a one-in-40,000 response rate (what direct marketers call a "conversion rate") for their offers.

A separate study—released in April 2005 by the Pew Internet and American Life Project—indicated that spam is changing the way people use the Internet. According to the survey, 53 percent of adult e-mail users in the United States said they trust e-mail less because of spam. About one in four Internet users avoid giving out e-mail addresses or set up special addresses when they believe they might attract spam. More should.

> People who use the free e-mail service at the Web site Hotmail.com collectively receive more than one billion pieces of junk e-mail a day. Such spam accounts for 80 percent of messages received—not including mail blocked by Hotmail's first line of anti-spam filters.

HOW SPAMMERS OPERATE

Spammers are crafty. They take notice of what is going on in the world. In the run-up to the Christmas season, pitches for products like toys and games dominate the mix; after the holiday binge, pitches for miracle diets take over.

As one Internet security expert says, "Spammers are evolving from slugs into tapeworms." For one thing, most no longer use text in their e-mails. So many filters reject the words *viagra*, *v!agra* or *vlagra* that

spammers create entire messages as images, without text, so there's nothing to filter. The most common subject header is a simple "hi," which is often used by legitimate personal e-mail (and therefore difficult to filter out).

How do spammers get your e-mail address in the first place? Some pay insiders to steal them. In February 2005, Jason Smathers—a 24-year-old former American Online software engineer—pleaded guilty to stealing 92 million screen names and e-mail addresses and selling them to spammers.

His actions lead to an avalanche of up to seven billion unsolicited e-mails.

Smathers entered his plea in U.S. District Court in Manhattan. Eventually, he was sentenced to 15 months in federal prison and ordered to pay restitution of between nearly $400,000.

Smathers told the judge that he had accepted $28,000 from someone who wanted to pitch an offshore gambling site to AOL customers. And he knew that the list of screen names might make its way to others who'd send e-mail solicitations.

Smathers sold the list to Nevada-based entrepreneur Sean Dunaway, who used it to send the gambling advertisements to the AOL subscribers.

The stolen list of 92 million AOL addresses included multiple addresses used by each of AOL's estimated

30 million customers. It's believed to be *still* circulating among spammers.

A HISTORY OF SPAM

Unsolicited bulk e-mail has been a problem of the Internet...as long as the Internet has been popularly used. And American Online has been a major channel for spam the whole time.

The September 2000 Iowa federal court decision *America Online Inc. v. National Health Care Discount, Inc.* established one early set of facts related to how spam was used...and how frustrated people responded to it.

National Health Care Discount (NHCD) provided discount optical and dental service plans to the public. It made arrangements with a number of self-employed sales representatives to market its services from leads provided by NHCD.

Starting in late 1997, various NHCD contractors—including one Forrest Dayton—began sending unsolicited bulk e-mail to AOL subscribers; this spam contained advertisements for NHCD's products.

The company paid contractors $1.00 for each lead they generated as a result of their activities.

Between 76 and 300 million pieces of spam advertising NHCD's products were sent to AOL subscribers between 1997 and 1999.

During this period, AOL had policies which prohibited subscribers from using AOL accounts to send spam to *other* AOL subscribers. It also prohibited "harvesting" e-mail addresses of subscribers from chat rooms for the purpose of sending them spam.

NHCD management knew that e-mail advertising its product was being sent to various people. But it was unclear whether management knew the details of *how* that e-mail was being sent.

Starting in July 1998, AOL sent several cease and desist letters to NHCD, requesting that it stop sending spam to AOL subscribers. NHCD replied that the e-mail was being sent by independent contractors that NHCD did not control.

Several million pieces of spam later, AOL sued NHCD, charging that NHCD's activities violated the U.S. Computer Fraud and Abuse Act (CFAA) and various other legal standards.

AOL asked the court to make a summary judgment and force NHCD to stop the spam. In making this request, AOL cited the CFAA, which prohibited "intentionally accessing a protected computer without authorization and as a result of such conduct, causing damage."

"Damage" under the CFAA was defined as:

> ...any impairment to the integrity or availability of data, a program, a system or in-

formation that... causes loss aggregating at least $5000 in value during any 1 year period to one or more individuals....

Separately, the CFAA prohibited a person or entity from "intentionally accessing a computer without authorization or exceeding authorized access, and thereby obtaining... information from any protected computer if the conduct involved an interstate or foreign communication."

The court could not conclude that the people who sent the spam in question—who were also AOL account holders—had "accessed [AOL's computers] without authorization" within the meaning of the CFAA. The court wrote:

...it is not clear that a violation of AOL's membership agreements results in "unauthorized access." ...AOL members, such as Dayton, obviously have "authorization" to access the AOL network.

According to the court, people who had permission to access a computer could only be held liable if they intended to cause damage; people who did *not* have authority to access a computer would be held liable so long as they caused damage—regardless of their intent.

The court also ruled that questions existed about whether NHCD was liable for the conduct of the e-mailers in question. So, it denied AOL's request. But that wasn't all. The court concluded:

AOL's problem, both for purposes of summary judgment and at trial, is showing specifically that NHCD's UBE, which by AOL's admission rep-

resents a mere fraction of the quantity of UBE
regularly forced through AOL's system, caused the
requisite damage contemplated by the statute.

In fact, the court questioned whether the CFAA
addressed spam at all. According to the court "real-
istically, no federal statute currently exists which
would prohibit a non-AOL member from sending
UBE to any number of AOL members' e-mail ad-
dresses, without ever accessing AOL directly."

MAKE AN EFFECTIVE COMPLAINT

You don't need to sue a spammer to interrupt his
bad work. In fact, lawsuits aren't usually effective.

The better way to handle spam is to make a com-
plaint to the ISP from which it originated. Internet
service providers (ISPs) are independent companies
that have to comply with various laws limiting the
use of spam. They don't usually send spam...but
they give Internet access to the crooks who do.

> ISPs sometimes claim they don't know what kind of
> e-mail—even bulk e-mail—their customers send. So,
> if you receive spam, you need to let the ISP know it's
> passing junk along.

To find out where spam originated, you need to
look at the e-mail headers. You can't just reply to
the message to give the spammer a piece of your
mind—because it's very easy to fake an e-mail ad-
dress. And many spammers do.

Here is a sample e-mail header (the final recipient's address is you@your.domain.com; just about everything else relates to the sender):

Received: (2228 bytes) by
<your.domain.com> via sendmail with
P:stdio/D:user/T:local (sender:
<29086328@compuserve.com>) id
m0xUFxr-001cL6C@your.domain.dom
for you@your.domain.com; Sat, 8 Nov
1997 10:50:35 -0800 (PST) (Smail-
3.2.0.98 1997-Oct-16 #12 built 1997-
Oct-28) Received: from jack.pacific.net.sg
(jack.pacific.net.sg [201.120.90.72]) by
your.domain.com (8.8.7/8.7.3) with
ESMTP id KAA01565; Sat, 8 Nov 1997
10:43:34-0800 (PST) From:
29086999@compuserve.com Received:
from pop1.pacific.net.sg
(pop1.pacific.net.sg [201.120.90.85]) by
jack.pacific.net.sg with ESMTP id
CAA25373; Sun, 9 Nov 1997 02:44:51
+0800 (SGT) Received: from
pop1.pacific.net.sg (hd58-
039.hil.compuserve.com
[199.127.238.32]) by
pop1.pacific.net.sg with SMTP id
CAA12179; Sun, 9 Nov 1997 02:43:10
+0800 (SGT) Received: from
mail.compuserve.com
(mail.compuserve.com (209.5.80.86)) by
compuserve.com (8.8.5/8.6.5) with SMTP
id GAA04211 for
<7890123456@aol.com>

It may look confusing, but there are some patterns that tell you everything you need to know. The

header can be broken into several sections, each beginning with the word *Received*.

- The first *Received* is from your e-mail server. This section lists the supposed sender, the message ID number and the time the message arrived.

- The other *Received: from* tags are from remailers that the spammer used to make it more difficult to track him down.

- The last *Received:from* entry in the header usually describes the originating server.

Find and write down the server domain and its IP address. This information appears in parenthesis in each *Received: from* entry.

Once you've located the origin of the spam, you can begin your complaint. Again, you need to make it with the spammer's ISP. Most ISPs have a dedicated address for complaints about spam or other abuses. This address is often abuse@domain.com—but may be different for a particular ISP.

Here are some guidelines to follow when preparing your complaint:

- Put the complaint before the body of the forwarded message.

- Forward the offending spam to the ISP. Do not cut, paste, and re-send it be-

cause it may create extra e-mail headers. Leave the headers intact.

- Keep your complaint short and non-abusive. The spam did not come from the ISP; it came from a user on the ISP's system. Write "I received this unsolicited commercial e-mail from one of your users. Please take the appropriate action to ensure this doesn't happen again."

- Only send one complaint per spam received. Most ISP's have an auto-reply system for messages sent to the abuse address. Sending multiple messages won't get a problem solved any faster.

- If your message bounces back as undeliverable, visit the ISP's site. Most ISPs will have an "acceptable use" agreement on their sites detailing how to contact them regarding member abuses.

BROADER STROKES

Of course, no one can spend all of his or her day researching original ISPs and making carefully written complaints. Most people who use the Internet are hoping for a broader pre-emptive solution.

Most online security experts agree that there are four components to a spam solution:

1) legislation,
2) public awareness,

3) responsibility of direct marketers and

4) technology.

The main legislative tool for fighting spam in the U.S. is the 2003 Controlling the Assault of Non-Solicited Pornography and Marketing (CAN-SPAM) Act. You *can* sue spammers under this law.

In the fall of 2005, a small California Internet service provider sued Kraft Foods Inc., alleging the food giant was responsible for thousands of illegal spam messages. Hypertouch.com founder Joe Wagner said his company had received 8,500 copies of an e-mail pitching Kraft's high-end coffee subscription service, Gevalia, in less than 12 months.

Wagner, who filed the suit in federal court in San Francisco, claimed he was entitled to $11.7 million in compensation for damages.

John Fallat, Hypertouch's lawyer, claimed the e-mail pitches violated the federal CAN-SPAM act and California's state anti-spam law because the addressing information in the messages had been faked. According to Fallat, the e-mails appeared to come from a sender who was not a real person, rather from a marketing firm hired by Kraft to sell coffee.

Such "fraudulent headers" were illegal under both federal and California spam laws.

Fallat said Wagner was entitled to $2.5 million from the CAN-SPAM claim—$100 per spam e-mail, with triple damages applied for willful disregard of the law. Wagner was also entitled to another $8.5 million, or $1,000 per spam, under California law.

Wagner said Hypertouch had continued to receive Gevalia spam, even after the lawsuit had been filed.

An e-mail sent in November 2005 appeared to come from a person named Sarah Miller at the Web site BreedingCoverage.com. But the IP address in the e-mail didn't resolve to BreedingCoverage servers, the lawsuit claimed, indicating the e-mail header information had been faked.

On March 26, 2005, representatives of Gevalia sent 761 similar spam e-mails claiming to be from 761 different people—indicating marketing companies were hiding behind fake names, the lawsuit said.

Hypertouch's attorney said:

> *These kinds of e-mails should not be coming from the Fortune 500. This is an important lawsuit because we want to send a message to big corporate America that... they are under an obligation to monitor and supervise third-party marketers to ensure they do not send out fraudulent e-mail.*

Wagner said he'd approached Kraft in November 2004 with evidence of spamming efforts and was ready to resolve things without a lawsuit.

Both Wagner and Fallat had filed spam-related lawsuits before. In March 2005, the two had sued BobVila.com for allegedly sending out spam. When he filed the later suit against Kraft, Wagner said he was in settlement conversations with BobVila.com. Evidently, he was making a practice of suing companies under the CAN-SPAM Act.

SPAM-SPEWING ZOMBIES

One of the biggest developments in the increase in spam volume through the early 2000s was the growing use of so-called "zombie" relays. These zombies (also sometimes called "bots") are personal and small-business computers hijacked by crooks and used as remote relays for torrents of spam e-mails.

> **Zombies allow spammers to pose as legitimate customers and get around blocks that Internet providers might have in place.**

Online viruses like "SoBig" turn infected computers into zombies that send out millions of unwanted messages without the owner's knowledge. Zombie networks are responsible for 50 to 80 percent of all spam, according to various estimates.

In early 2005, the best-known automatic spam-sending software introduced a new feature that stealthily gets around key anti-spam filters. SendSafe is popular with spammers because it is easy to use. With easy-to-use bulk e-mailing capabilities, the program can turn anyone into a spammer overnight. It allows crooks to "rent" lists of compromised home computers, which are then used as an army of spam-forwarding zombies.

Internet security experts say that SendSafe and a competing program called Direct Mail Sender are used by a majority of spammers.

Spam filters work hard to keep known spam zombies on "blacklists." But the fast-growing number of compromised home machines—according to some sources, 100,000 machines become infected every week—makes the job difficult.

And SendSafe's anonymous authors try to make it even harder. In February 2005, they installed a new feature that allowed spammers to make their zombie-sent e-mail appear as if it had been sent directly from an ISP's own system.

Since it's not feasible to filter out an entire ISP's e-mail, the new SendSafe program foiled the entire blacklisting system.

In May 2005, the FTC suggested that home computer users who unwittingly send out spam e-mail should be disconnected from the Internet until their machines are fixed, the U.S. Federal Trade Commission said.

The FTC said it would ask 3,000 Internet providers around the globe to make sure that their customers' computers haven't been hijacked by spammers who want to cover their tracks and pass bandwidth costs on to others.

According to the FTC, Internet service providers should identify computers on their networks that are sending out large amounts of e-mail and quarantine them if they are found to be zombies. They should also help customers clean their machines and tell them how to keep them safe in the first place.

Most U.S. Internet providers had already taken the steps outlined in the FTC's letter—but most were concerned about taking care not to squelch legitimate mail in the process.

DESPERATE MEASURES

With the federal government talking about shutting down unwitting zombies, it should come as little surprise that other groups advocate even more extreme responses.

Some anti-spam activists argue for a kind of Internet-based vigilantism. During the summer of 2005, a California company suggested letting thousands of users collaborate to disable the Web sites spammers use to sell their wares.

Blue Security's so-called "Blue Frog initiative" would effectively launch a denial-of-service attack against ISPs that send spam...and shut them down by overwhelming them with fake traffic.

Here's how the initiative would work:

- When users add e-mail addresses to a "do-not-spam" list, Blue Security would create additional addresses—known as *honeypots*—designed to do nothing but attract spam.

- If a honeypot received spam, Blue Security would warn the spammer to stop. Then, it would trigger the Blue Frog software on a user's computer to send a complaint automatically.

- Thousands complaining at once would knock out an ISP (or Web site) and, thus, encourage spammers to stop sending e-mail to the "do-not-spam" list.

Eran Reshef, Blue Security's founder and chief executive, said Blue Frog merely enabled users to make complaints collectively that they would otherwise have sent individually.

Others disagreed—saying it was no better than hacking. "It's the worst kind of vigilante approach," said John Levine, a board member with the Coalition Against Unsolicited Commercial E-mail. "Deliberate attacks against people's Web sites are illegal."

PREVENTING SPAM

The easiest way to prevent spam from reaching your computer is to use any of several e-mail filter programs. (McAfee's SpamKiller is probably the best-known; Microsoft and Earthlink offer filters as add-ons to operating systems and Internet services.)

These programs treat spam like a virus—recognizing known spam content and removing it from a consumer's e-mail in box before he ever sees it.

The programs usually connect to a user's inbound e-mail server and scan incoming messages for addresses of known spammers. They use advanced filtering protocols that examine the subject line, body text, message headers and country code for trigger words or phrases commonly found in spam.

Once detected, the spam is automatically removed from the user's inbox and quarantined for future review, if necessary.

The filters also help track the spam back to its source ISP and may automatically send complaints to that service provider. Some return false "bounced" e-mail failure messages—which will make the crook believe the user's address is no good.

However, some experts warn that these filters can reject legitimate e-mail.

Carl Hutzler, America Online's anti-spam coordinator, suggests that ISPs and other Internet access companies should focus instead on keeping spam from *leaving* their systems in the first place.

One example: In 2005, EarthLink Inc. began phasing in a requirement that customers' e-mail programs submit passwords before it (EarthLink) will send out their e-mails. Like most ISPs, EarthLink had previously focused on making sure only that a computer was associated with a legitimate account.

> But some anti-spam experts say ISPs like AOL and Earthlink can do more to stop spammers from signing up for accounts in the first place. These critics argue that the ISPs are slow to weed out crooks because they're paying customers.

There are other techniques that ISPs can use to combat spam from flowing through their systems.

EarthLink and AOL also have implemented poli-
cies that force customers to route e-mail through
the ISPs' own mail servers—instead of sending mes-
sages directly to the Internet.

Other ISPs are starting to adopt stricter outbound
policies, as well. They can block or place speed lim-
its on e-mail that exceeds a predetermined hourly
or daily limit. When users of Microsoft's Hotmail
service try to send a large number of messages, they
are prompted to type in random letters displayed
on the screen. Presumably, spammers using zom-
bies wouldn't be able to do it.

PREVENTION TIPS

Here are some effective ways to keep your e-mail
address safe and your computer from being turned
into a zombie or otherwise abused by spammers:

- Removal Addresses: Don't respond to
 the "removal request" e-mail address
 that shows up in some spam. Doing so
 may land you on the list of dozens of
 other spammers. It's better to complain
 directly to the spammer's ISP.

- Usenet Newsgroups: Don't post mes-
 sages to a newsgroup or in a chat room
 using your real e-mail address.

- Personal Web sites: If you have your
 own Web site, don't put a link to your
 e-mail address. Instead, offer users a
 form they can use to contact you. There
 are several online resources for creating
 these forms.

- Online Services: Avoid user profiles that include contact information. Find out if you can request exclusion from any member directories. Also, ask if the service offers any mail filters to keep messages from known spammers out of your mailbox.

- Online Software Registration: Always double check which options you are checking when registering your software. Online registration programs often let you choose to have your address added to a list of addresses so the business can send you e-mail. Sometimes you have to uncheck a box if you don't want advertisements.

THE LAWS AREN'T SO STRONG

In April 2005, the man convicted in the nation's first felony case against illegal spamming was sentenced to nine years in prison.

Jeremy Jaynes had been considered among the top 10 spammers in the world at the time of his arrest two years earlier. He used massive Internet mailings to peddle pornography and sham products or services such as a bogus "FedEx refund processor."

Thousands of people fell for his e-mail solicitations; at its height, Jaynes' operation grossed nearly $750,000. A month.

Jaynes—who lived in North Carolina and sent his spam from computers there—was convicted in November 2004 for using false Internet addresses and aliases. He sent most of his spam ads through an AOL server in Loudoun County, Virginia (where America Online is based).

While prosecutors presented evidence of 53,000 illegal e-mails going back nine years, they said that Jaynes was responsible for spewing out 10 million e-mails a day. They focused on a small sliver of all of Jaynes' junk e-mails because, under Virginia law, sending unsolicited bulk e-mail itself is not a crime—unless the sender masks his identity.

Jaynes' attorney said that he planned to appeal.

And even the judge sentencing Jaynes admitted the case and the law had weaknesses. He allowed Jaynes to remain free on bail while his lawyers prepared their appeal. And, a month earlier, he'd dismissed the charges against one of Jaynes codefendants on the grounds that he could find no "rational basis" for a guilty verdict and suggesting that jurors might have been confused by technical evidence. (Another codefendant had been acquitted.)

So, legislation—the key tool for fighting spam—remains a somewhat wobbly proposition. You're better off making sure that you don't fall for bogus offers...and that your computer isn't drawn into a zombie army.

14

SPYWARE

In April 2005, New York State Attorney General Eliot Spitzer sued Los Angeles-based Intermix Media, Inc., one of the leading Internet marketing companies in the U.S. The lawsuit alleged that Intermix was the source of spyware and adware secretly installed on millions of home computers.

In a prepared statement, Spitzer said:

> *Spyware and adware are more than an annoyance. These fraudulent programs foul machines, undermine productivity and in many cases frustrate consumers' efforts to remove them from their computers. These issues can serve to be a hindrance to the growth of e-commerce.*

The suit followed a six-month investigation in which Spitzer's office had concluded that Intermix had acted illegally.

Spitzer's investigators found that, along with its advertised programs, Intermix secretly installed a number of ad-delivery programs on the computers of unaware consumers. One such program was called "KeenValue" and it delivered pop-up ads to its un-

suspecting users. Another program, called "IncrediFind," redirected Internet addresses to Intermix's proprietary search engine. Other programs placed advertising "toolbars" on users' screens.

Spitzer's investigators documented at least 10 separate Web sites from which Intermix or its agents loaded spyware on to consumers' computers with little or no disclosure. The lawsuit charged that Intermix used these sites sneak more than 3.7 million programs into New Yorkers' computers—and tens of millions more to users elsewhere.

Intermix didn't just sneak the software onto computers; it also went to great lengths to protect its spyware and adware from being discovered or removed. Some programs were hidden in unlikely locations on computers and could not be removed through usual "Add/Remove" functions. The programs omitted "un-install" applications—and even reinstalled themselves after being deleted.

The investigators said Intermix spyware often slowed infected computers considerably and caused them to crash. They added that some New York-area computer repair shops blamed spyware for more than half crashed computers that they saw.

In the lawsuit, Spitzer's office sought a court order enjoining Intermix from secretly installing spyware, an accounting of all revenues made on these products and payment of various penalties. The lawsuit based its demands on New York's General Business

Law (which prohibits deceptive business practices) and—perhaps more interesting, legally—the state's laws against trespassing.

> Significantly, Spitzer's suit did not involve the corporate advertisers—including a number of Fortune 500 companies—whose goods and services were touted in Intermix ads.

Intermix denied any fraud or use of spyware. A spokesman said that many of the practices in dispute had been established by previous management and that the company was committed to Internet advertising industry best practices.

WHAT, EXACTLY, IS SPYWARE?

Most Internet security experts consider spyware any of various programs that redirect Web addresses, add toolbars and deliver pop-up ads. Others add more troubling attributes—such as monitoring people's computer habits, slowing down systems and recording personal information.

This is much more serious than spam, because spyware makers can surreptitiously track Web users—and even steal their identities.

A number of crooked practices are often associated with spyware:

- reprogramming the start page on a user's Internet browser,

- logging keystrokes to capture passwords and other sensitive data, or

- launching pop-up ads that can't be closed without shutting down the computer.

In the Internet advertising industry, firms make a distinction between adware—installed with a user's consent, however minimal—and spyware, which sneaks its way onto computers.

But many experts reject that thin distinction. In congressional testimony from 2004, C. David Moll—CEO of antispyware firm Webroot Software Inc.—said in a test of one million PCs that his firm conducted, 90 percent were infected with spyware. He also said 250,000 Web sites included secret code to sneak spyware onto computers. In one spyware installer program his company found, users presented with a dialog box could only say "yes" to download; the "cancel" button had been disabled.

Internet users worried about spyware and adware are shunning specific Web sites, avoiding file-sharing networks and even switching browsers. Some have stopped opening e-mail attachments without first making sure they are safe, according to a survey released in July 2005 by the Pew Internet and American Life Project.

According to that Pew survey:

- 48 percent of adult Internet users in the U.S. have stopped visiting specific

Web sites that they fear might be harboring unwanted programs.

- 25 percent stopped using file-sharing software, which often comes bundled with programs to display ads that subsidize its development.

- 18 percent have started using Firefox or other so-called "alternative" Web browsers. Why? Too many unwanted programs sneak past security flaws in Microsoft's Internet Explorer.

Users hit by spyware or adware were more likely than others to change their habits.

The survey also found that 43 percent of Internet users said they'd been hit with spyware, adware or both. But those who reported spyware were more likely to have engaged in "risky" behavior such as playing online games and visiting adult sites. (High-speed Internet users also faced greater risks.)

SPYWARE TRICKS

One favorite trick that spyware companies use is offering free anti-spyware scans—which are bogus and actually *install* spyware on computers.

In March 2005, the U.S. Federal Trade Commission shut down one such company. According to the Feds, Washington-based software maker MaxTheater Inc. scared consumers into buying software through pop-up ads and e-mail that warned their computers had been infected with malicious monitoring software.

> The company's free trial version of its Spyware As-
> sassin program turned up evidence of spyware—
> even on machines that were entirely clean. And the
> full version of Spyware Assassin (which cost about
> $30) didn't actually remove spyware, the FTC said.

A U.S. court ordered MaxTheater to suspend its activities until a hearing could determine the existence and extent of its fraudulent activities.

The boom in spyware had some lawmakers suggesting more dramatic action. Several asked why Congress couldn't authorize something like the popular Do Not Call List, which largely ended dinner-time interruptions by telemarketers. But several such bills had been bogged down by arguments over technical language.

MICROSOFT AND SPYWARE

Speaking at an Internet security conference in February 2005, Microsoft Chairman Bill Gates announced a new campaign in which his company would give consumers a free tool for combating spyware. Microsoft would sell a more sophisticated anti-spyware product to businesses.

Microsoft had recently announced plans to acquire a company whose software protected corporate networks from spyware, viruses and other threats. Software industry analysts predicted that the deal for Sybari Software Inc. would hurt security companies like Symantec and McAfee.

New York-based Sybari had about 10,000 clients for software that scanned e-mail systems to prevent unwanted programs and attacks from being accepted. And Sybari was only the latest of several companies that Microsoft had acquired to help establish a presence in the online security sector.

In 2003, it had acquired a Romanian antivirus firm, GeCAD Software; in late 2004, it bought Giant Company Software Inc.—which made tools to remove spyware. And, a few months after the Sybari acquisition, Microsoft bought FrontBridge Technologies Inc.

FrontBridge offered a slightly different approach to protection from viruses and spyware; rather than developing software that companies loaded on their systems, it offered an "outsourcing" service. Customers would route all incoming e-mail to a remote location, where FrontBridge computers would make sure the e-mails were clean before routing them back to the customer.

> These acquisitions came amid a series of attacks against Microsoft's Windows operating system. Many spyware programs exploit weaknesses and complexities in Microsoft's code-heavy programs.

At the same time, Microsoft was also confounding some industry analysts by negotiating to buy Claria, one of the most despised adware companies in the online world.

California-based Claria—which had been known as Gator before a 2003 corporate name change—was infamous for its pop-up ads and software that tracked people's online activity. Gator adware had frequently been denounced by privacy advocates for its intrusiveness. The company had been sued frequently by online publishers, including The New York Times Company, over its pop-up ads.

About the same time it changed its name, Claria management insisted the company was moving away from adware (it never admitted making spyware) and toward "personalized services," like delivering local weather information and software that helped users personalize Web pages.

> **Software tailored to individual preferences and browsing habits opened the door to personalized advertising—a market of great interest to Microsoft and competitors like Google and Yahoo!**

Some experts claimed, a bit ironically, that Microsoft and Claria had been *unwittingly* working together for a long time. Claria's advertising reach came from a long history of using paid "affiliates" to exploit security "holes" in Microsoft's operating system to install the software without user permission.

And others noticed that—about the same time it was negotiating with Claria—Microsoft's AntiSpyware program lightened its response to Claria programs. According to Eric Howes of SpywareWarrior.com:

Several sources have now confirmed that Microsoft downgraded its detections of Claria's adware products in the latest update to Microsoft AntiSpyware.... Where Microsoft AntiSpyware used to detect Claria's products and present users with a Recommended Action of "Quarantine," {it} now presents users with a Recommended Action of "Ignore."

Ultimately, the rumored Claria deal didn't occur. But the softer stance on Claria spyware and speculation about an acquisition damaged Microsoft's efforts to portray itself as a trustworthy company. This caused problems for the software giant.

Among the proposals being considered by the e-mail industry and Internet standards community was Microsoft's Sender ID and its closely related cousin, the "Sender Permitted From" or SPF standard.

Both SPF and Sender ID use text records entered into a domain's DNS entry that define what IP addresses should be permitted to send e-mail for that domain. These definitions embedded in the sender's DNS records are then queried and parsed by the receiving server to determine whether to accept or reject a particular piece of e-mail.

SPYWARE STRATEGY

Another favorite trick of spyware crooks: using children's sites as launching grounds for attacks.

Children's Web sites host a glut of adware. Spyware makers target kids in a well-planned effort to slip past parents and get ad-generating software onto home computers.

Over a three-month period, a group product manager in Symantec's consumer division took new PCs out of their boxes, connected them to the Internet without modifying any of the default settings in Windows XP and surfed well-known sites in several categories, ranging from kids and sports to news and shopping.

Testers went to name-brand Web sites and spent 30 minutes to an hour reading or interacting with sites. They tried to act like real-world browsers by reading articles, interacting with site features— but not looking to accumulate files by downloading. Then they ran spyware detection software and counted up what kind of security risks and how many files had been installed on the machines.

Children were the biggest target for spyware makers, by far. The trip to several kids' sites installed a whopping 359 pieces of adware on Symantec's PCs, five times more than the nearest category rival, travel. Popup ads proliferated on the machines after that, making them virtually unusable.

They sites basically convince kids to install the adware that their parents might have avoided.

The "cleanest" category was shopping. Shopping sites don't want to distract you with pop-ups. They

have you there, and the site operators are only thinking "let's complete the sale," not how to install adware on their sites.

PREVENTION FRUSTRATED

Computer security experts talk in different terms; the focus on *potential threats*—an umbrella definition that includes spyware, adware and other programs that:

- impair users' control over their systems, including privacy and security;

- impair the use of system resources, including what programs are installed on their computers; or

- collect, use and distribute personal or otherwise sensitive information.

One phishing scam used the link in the e-mail to direct the users browsers to a site to first download keyboard logging spyware before redirecting the user to the genuine Internet banking Web site. This spyware captured the login information entered, and sent this information to the crooks via a remote computer on the Internet.

> Spyware programs can be used to facilitate the unauthorized use of computers for things like spam relay and denial of service attacks. Spyware programs can also lead to identity theft, and the theft of intellectual property, as well as data leaks, and the degradation of computer performance.

In the broadest terms, there are four ways that spyware presents a threat:

1) data security;

2) online privacy;

3) hardware performance; and

4) Internet commerce generally.

The primary risk posed by computer viruses is data corruption; the primary risk posed by spyware is more subtle. It's data security.

As the New York Attorney General argued, spyware is the online equivalent of someone trespassing into your home. Information gathered by spyware programs includes:

- browsing habits and sites visited;

- search terms used;

- advertisements clicked on;

- bookmarks and favorites;

- downloaded content;

- e-mail and IM conversations;

- usernames and passwords; and

- personal information, such as Social Security numbers.

As we've noted, spyware can hurt computer and network performance. But there's also a larger economic impact: It soaks up tech support time and resources. For example: According to Dell Computer, one of every five customer support calls received in 2004 were related to spyware.

Some crooked Web pages use a form of spyware to inject programs onto accessible computers—even when there is no interaction from the user. This practice is known as a *drive-by download*.

Sites with drive-by downloads often use URLs that are commonly misspelled versions of popular sites. For example, at one point people looking for Google's site but typing www.googkle.com became the victims of drive-by downloads.

THE PROBLEM AND WHAT TO DO

Spyware is a big problem. Webroot's survey of more than a million PCs revealed that 88 percent of home computers and 87 percent of business computers were infected with *some* form of spyware.

Some computer experts include cookies—small bits of code designed to simplify subsequent visits that legitimate commercial Web sites install on visiting computers—in their definitions of "spyware." This is probably an exaggeration. Cookies are small enough that they don't harm a computer's functions; they aren't designed to cause trouble.

Spyware is not like a virus designed by a script kiddie who just wants to show off. It's part of a calculated business plan used by criminals.

Traditionally, the primary methods for fighting spyware have been reactive. Anti-spyware companies

concentrated on fixing computers that had already been infected.

But, to fight spyware, you need software that can do more than just look at a file, refer to a list of known bad ones and identify it as good or bad.

> Spyware often imitates legitimate files, or finds ways of hiding itself on your system. For this reason, programs like AntiSpyware use logic based partially on feedback from bots and other tools to examine the "genetic fingerprints" of files and determine whether those files are valid.

The best way to protect yourself from spyware is to download and use anti-spyware software like:

- Ad-Aware (http://www.lavasoftusa.com)
- Microsoft Windows AntiSpyware (http://www.microsoft.com)

Both of those programs are free. If you can afford to pay, programs like the Norton Anti-Virus suite and SpywareDoctor offer some advantages—including frequent updates.

> Updates are important on many fronts. Make sure you are using the latest version of your Web browser, and—if you use Internet Explorer—set the security settings to high.

15

WHAT THE
LAW CAN—AND
CAN'T—DO

Throughout this book, we've considered how federal, state and local law enforcement agents respond (or don't respond) to scams and swindles. In many cases, they are limited in what they can do to prosecute scams; in some cases, the law doesn't even consider swindles crimes.

This all comes as a big shock to many of the people whose money has been taken by crooks.

In this chapter, we'll take a look at the actions that various U.S. federal agencies can take with regard to investigating or prosecuting financial frauds. In many cases, these actions will be fewer and less effective than you would expect.

U.S. SECRET SERVICE

The U.S. Secret Service investigates crimes associated with financial institutions—and many financial frauds. Its Financial Crimes Division (FCD) plans, reviews and coordinates criminal investigations involving financial systems crimes, including:

- bank fraud;

- access device (credit and debit card) fraud;

- telemarketing fraud;

- telecommunications fraud (cellular and hard wire);

- computer fraud;

- crimes involving automated payment systems and teller machines;

- crimes involving direct deposit transactions;

- forgery, alteration or false claims involving U.S. Treasury Checks, U.S. Savings Bonds, U.S. Treasury Notes, bonds, and bills;

- electronic funds transfer fraud (including fraud involving Treasury disbursements or payment systems);

- crimes involving the Federal Deposit Insurance Corporation.

The FCD also coordinates the activities of the U.S. Secret Service Organized Crimes Program and oversees money laundering investigations. So, the Secret Service is probably the main federal agency that deals with financial scams and swindles—more involved than the higher-profile FBI.

Legally, the Secret Service has "concurrent jurisdiction" with the Department of Justice—home to the FBI—to investigate both civil and criminal fraud against federally-insured financial institutions. According to the Secret Service Web site:

{This} program distinguishes itself from other such programs by recognizing the need to balance traditional law enforcement operations with a program management approach designed to prevent recurring criminal activity.

Like most law enforcement agencies, the Secret Service tries to avoid talking in specifics about how it responds to particular crimes; but it does talk about general policy goals. Its Web site references an American Banking Association survey which concluded that the two major problems in the area of bank fraud were:

1) fraudulent production of negotiable instruments (primarily, checks) through the use of what has become known as "desktop publishing," and

2) access device fraud.

And Secret Service agents point out that the term "access device" refers to more than just credit cards.

The relevant federal laws apply to crimes involving access device numbers, automated teller machine (ATM) hardware, computer passwords, personal identification numbers (PINs) used to activate ATMs, credit or debit card account numbers, long-distance access codes and the computer chips in cellular phones that assign billing.

So, their definition of the term "access device" covers almost everything we've considered in this book. Except maybe the Russian brides.

COMPUTER FRAUD

U.S. law gives the Secret Service specific responsibility for the investigation of fraud and related activities concerning computers described as "federal interest computers." It also investigates cases in which computer technology has been used in traditional Secret Service violations—such as counterfeiting and the creation of false ID documents.

The Secret Service considers computer fraud a major front in its crime-fighting responsibility:

> *Computers are being used extensively in financial crimes, not only as an instrument of the crime, but to hack into databases to retrieve account information; store account information; clone microchips for cellular telephones; and scan corporate checks, bonds and negotiable instruments, that are later counterfeited using desktop publishing methods.*

To deal with these frauds, the Secret Service FCD developed an Electronic Crimes Branch that houses the equipment and personnel devoted to dealing with computer crimes.

Finally, the Secret Service is involved in numerous task forces with federal, state, county, city and local law enforcement agencies. Several of these task forces specifically target international organized crime groups.

These groups are not only involved in financial crimes; agents say that the proceeds obtained from

financial fraud are diverted toward other criminal enterprises—including political terrorism.

THE FBI, SLOWER TO THE SCENE

The FBI concentrates its investigative efforts on scams that involve losses of at least $100,000. Given the growing number of scams that occur every year, this is understandable. But—as we noted in the Sweetheart Scam sections of Chapter 7—victims of not-so-grand frauds often end up frustrated and angry that the Feds won't bother with their cases.

> As we've noted before, local prosecutors may file charges against small-time crooks and con artists...but they end up waiting for the chance of a traffic violation or other crime to catch these crooks.

As a result of this low-priority pursuit, some scammers gleefully taunt law enforcement organizations. And the FBI seems to suffer more of these taunts that other agencies.

In February 2005, a series of malicious spam e-mails resulted in several unusual warnings from the FBI.

The e-mails took several forms: one asked recipients to respond and confirm personal information; another accused recipients of visiting "illegal" Web sites; and a third asked recipients to open an attached form—which activated the zombie program.

What made these spam e-mails stand out from the sea of similar pitches was their return addresses. They

seemed to come from the FBI, DHS and other federal authorities.

Programming fake "From" addresses in e-mails is not a new trick among hackers and spammers. But, traditionally, they had avoided pretending to be federal agents.

On its Web site, the FBI warned:

> *These e-mails did not come from the FBI. Recipients of this or similar solicitations should know that the FBI does not engage in the practice of sending unsolicited e-mails to the public in this manner. Opening e-mail attachments from an unknown sender is a risky and dangerous endeavor as such attachments frequently contain viruses that can infect the recipient's computer.*

The FBI said it was investigating. But the agency was reeling from other problems. A few weeks prior, it had been forced to stop using fbi.gov e-mail accounts for communication with the public because of internal security breaches.

A spokeswoman said that problem and the phony "From" addressed spam appeared to be unrelated. But the combination confirmed the FBI's reputation for being somewhat dull about online scams.

PREVENTION VS. PROSECUTION

Despite their policy statements otherwise, law enforcement agencies like the Secret Service and the FBI invariably focus more on prosecuting criminals than preventing crimes. This is a bias buried deep in their original missions.

So, what government agency is supposed to work on prevention? In the U.S., the answer is the Department of Homeland Security (DHS). If only that were a more satisfying answer.

The DHS has had trouble filling its chief computer security position. The first person to hold the job, a former private-sector entrepreneur, resigned abruptly after little more than a year on the job—amid reports that he was frustrated with his lack of authority. He was replaced by his chief deputy, a career bureaucrat with a better approach for dealing with public-sector power dynamics.

The results have not been great for the U.S. government's tech security. In 2005, a report from the House Government Reform Committee concluded that overall security of computer systems inside the largest government agencies had improved slightly from the year before—but still earned a barely passing grade.

> Seven of the 24 largest federal agencies—including the Department of Homeland Security—received failing grades.

This poor security performance dampens efforts by some U.S. policy makers to impose regulations that would compel private companies and organizations to enhance their own security. Industry groups counter that the government needs to improve its computer security before requiring businesses to make such changes.

THE FEDS *RELY* ON DATA BROKERS

In the spring of 2005, when data brokers like LexisNexis's Seisint unit were making news for data leaks, many politicians and policy makers called for limits on the information that these brokers sell.

"My conclusion is we need federal legislation," said Sen. Arlen Specter (R-PA) during one of several Capitol Hill hearings on regulating data brokers.

Sen. Charles Schumer (D-NY) proposed a bill that would require data brokers to screen clients and provide them with no more information than they need.

Sen. Dianne Feinstein (D-CA) proposed a nationwide disclosure law, based on the state-specific law in place in California. She said that consumers would still have been ignorant of the data leaks at ChoicePoint and LexisNexis if not for the California law.

Feinstein also wanted information brokers to be forced to ask permission from people to sell their sensitive personal information. "The ChoicePoint situation is perhaps the biggest indication of the vulnerability and lack of protection of individuals' personal data," she said.

And, about the same time, Federal Trade Commission Chairman Deborah Platt Majoras told the Senate Banking Committee that private companies should be forced—by law—to protect consumers' information from identity theft. She said that existing laws weren't strong enough to ensure that data brokers handled Social Security numbers and other details responsibly.

"I believe there may be additional measures that benefit consumers," she said. "We think that we ought to look at a broader security standard. As you say, we have a patchwork of laws today."

> The senators and the FTC Chairman failed to acknowledge one important fact during their hearings: The U.S. federal government is one of the data brokerage industry's biggest customers.

Since the early 1990s, government agencies like the Internal Revenue Service, the DHS, the Social Security Administration and a number of state Departments of Motor Vehicles have contracted with companies like ChoicePoint, LexisNexis and Acxiom to provide data on everyone from deadbeat dads to drunk drivers.

The IRS works especially closely with the data brokers. For example, in June 2005—just weeks after the hard talk from Senators Specter, Schumer and Feinstein—it awarded ChoicePoint a five-year, $20 million contract to provide public records that the IRS could use to "locate assets owned by delinquent taxpayers."

In light of ChoicePoint's security leaks involving consumer data, the IRS ordered a security review as a condition of the contract. But IRS staffers didn't seem worried about leaks—a spokesman noted that the IRS had contracted with ChoicePoint in the past and had experienced no security problems. Of which it was aware.

ChoicePoint isn't the only data broker with close government ties. Acxiom seems to have carved out relationships with the Social Security Administration; and Seisint continues to use federal money to build the Multi-State Anti-Terrorism Information Exchange (MATRIX).

The upshot of all this: Although politicians posture about protecting consumer financial data, the U.S. government counts on the aggressive use of personal data to collect taxes, fines and other revenue. It's not likely to crack down on its partners.

BACKGROUND CHECKS

One of the main reasons that the federal government contracts so often and so heavily with data brokers is that it's not able to administer comprehensive background checks on benefits applicants— or job applicants—effectively.

Despite worries of some civil libertarians about statist power grabs like the USA Patriot Act, the government does not have complete data on all residents. It does a poor job of managing data from its own federal courts...let alone the vast system of local courts that generate their own legal records.

> So, the federal government contracts with private-sector companies to access its own information.

Law enforcement experts warn that even the best national private-sector databases are often full of holes

and missing data. Spotty participation by the nation's 3,100 county courts and a hodgepodge of data formats make national crime databases inexact and incomplete.

Most criminal records are stored in county courthouses. In some states, the various counties report their data to a state law enforcement agency—such as Texas' Department of Public Safety. In other states—such as California—some counties sell their data individually to private firms. Other counties refuse to sell the data at all.

Companies like ChoicePoint gather their information from each relevant state and county agencies, supplemented sometimes with data on inmates purchased from state and county jails.

Relying on local agencies means relying on court clerks to update the information regularly. Some do so every day; others, every quarter. Some update sporadically. One Texas county went 18 months without updating its data.

Making matters worse: Each jurisdiction may have slightly different definitions for various crimes. A felony in one state may be a misdemeanor in another.

In an ironic twist, most "national" criminal databases don't include federal convictions. Records of those crimes—which include convictions for Internet child pornography—are filed in federal district courts and stored in a separate database.

Complicating matters further: Sex offences are generally stored in entirely separate databases, maintained by state agencies. That means finding former sex offenders requires an additional database check. While many of these checks are now made freely available on states' Web sites, others require handwritten or in-person requests.

All of this makes background research a tough thing to do well.

ChoicePoint's "NatCrim" file contains 200 million records from every state, making it perhaps the most useful tool for organizations trying to find fugitives, former criminals and other bad actors.

> **But even ChoicePoint concedes that national crime database searches offer incomplete results. The company admits on its Web site that every database search has limitations and "should always be used along with policies and procedures that help to protect children and other vulnerable populations."**

At best, such computer database searches can be a supplement to more thorough background checks of job applicants. But—in many situations—the quick computer database search is all that employers or law enforcement agencies have time and money to do.

16

SIMPLE THINGS YOU CAN DO TO PROTECT YOURSELF

Throughout this book, we've discussed various steps that consumers can take to protect themselves against common scams and swindles. In this final chapter, we summarize the best advice and tips.

CREDIT CARD FRAUD PREVENTION

- When possible, pay cash for meals in restaurants. If you use a credit card, consider excusing yourself from the table and meeting your waiter near the cashier station—so that you can keep your card in sight.

- If you use a credit card in a store, keep it in sight at all times.

- Never enter personal information—particularly credit card numbers—on any Web site, form or other location that you reached through a hypertext link.

- If you plan to use a card online, make sure that you have typed the URL for the Web site yourself. That's the best way to make sure you are in the site

you intend to be—and not some knock-off site.

- Reputable Web sites provide real contact information—a physical address rather than merely a post office box and a working phone number. Don't use your card on a Web site that doesn't provide this information.

- Be cautious when responding to special offers (especially made through unsolicited e-mail).

- If you are going to purchase an item via the Internet, use a credit card—rather than a debit card. If something goes wrong, it's easier to dispute charges on a credit card.

- Make sure the transaction is secure before you send credit card numbers. Secure sites will usually have a security certificate issued by VeriSign, Thawte or other independent verifier.

WHEN CARD FRAUD OCCURS

- Report the crime to the police immediately. Get a copy of your police report or case number. Credit card companies, your bank, and the insurance company may ask you to reference the report to verify the crime.

- Contact all of your credit card issuers. Get replacement cards with new account numbers and ask that the old

account be processed as "account closed at consumer's request" for credit record purposes. Follow up with a letter to the credit card company that summarizes your request in writing.

- Keep a log of all conversations with authorities and financial institutions. Buying a composition-style notebok or diary for this purpose is a good, low-tech idea.

- Review your billing statements carefully after the loss. If they show any unauthorized charges, it's best to send a letter to the card issuer describing each questionable charge.

IDENTITY THEFT PREVENTION

- Protect your Social Security number. You have to give your Social Security number for employment and tax purposes; it's not necessary for most day-to-day transactions.

- Be prepared to say "no" to some requests for your personal information.

- Don't put your Social Security Number or driver's license number on your checks.

- Carefully destroy papers you discard, especially those with sensitive or identifying information. Cross-cut paper shredders are a good investment in ID theft prevention.

- Be suspicious of telephone solicitors. Never provide information unless *you* have initiated the call.

- Order and closely review copies of your credit report from each national credit reporting agency once a year.

- Empty your wallet of extra credit cards and IDs.

- Shred pre-approved credit applications, credit card receipts, bills, and other financial information you don't want before discarding them in the trash or recycling bin.

- Remove your name from mailing lists for pre-approved credit lines by calling 1-888-5-OPTOUT (1-888-567-8688).

- Remove your name, phone number and home address from marketing lists by contacting the Direct Marketing Association (www.the-dma.org) . This won't prevent your name from being placed on *all* marketing lists, but it removes your information from many of them.

- Make sure that your PIN numbers cannot be observed by anyone while you're utilizing an ATM or public telephone.

- Never leave receipts at bank machines, bank counters, trash receptacles or unattended gasoline pumps.

- Memorize your Social Security number and all passwords. Do not record them on any cards or on anything in your wallet or purse.

- Promptly remove mail from your mailbox after delivery. If you're away, arrange for a friend or neighbor to pick up your mail.

- Deposit outgoing mail in post collection boxes or at your local post office.

- Never put your credit card or any other financial account number on a postcard or on the outside of an envelope.

IF YOUR IDENTITY IS STOLEN

- Contact your local police department to file a criminal report.

- Report the theft to the three major credit reporting agencies, Experian, Equifax and TransUnion Corporation, and do the following:

 1) Request that they place a fraud alert and a victim's statement in your file.

 2) Request a copy of your credit report to check whether any accounts were opened without your consent.

 3) Request that the agencies remove inquiries and/or fraudulent accounts stemming from the theft.

- Notify your bank(s) and ask them to flag your account and contact you regarding any unusual activity.

- Notify the Social Security Administration and your local Department of Motor Vehicles of your identity theft.

- Notify the passport office to be watch out for anyone ordering a passport in your name.

- Document the names and phone numbers of everyone you speak to regarding the incident. Follow-up your phone calls with letters. Keep copies of all correspondence.

The following is a list of addresses and numbers to the three major U.S. credit bureaus:

Equifax Credit Information Services
Consumer Fraud Division
P.O. Box 105496
Atlanta, Georgia 30348-5496
Tel: (800) 997-2493
www.equifax.com

Experian
P.O. Box 2104
Allen, Texas 75013-2104
Tel: (888) EXPERIAN (397-3742)
www.experian.com

Trans Union
Fraud Victim Assistance Department
P.O. Box 390
Springfield, PA 19064-0390
Tel: (800) 680-7289
www.transunion.com

SURFING THE INTERNET SAFELY

- Don't e-mail your personal data unless you use encryption technology.

- Be very careful when giving information on unknown Web sites, especially ones found in spam e-mails.

- Don't give out your checking account information on the Internet, unless you are dealing directly with your bank's Web site.

- Make sure every transaction you engage in on the Internet is over a secure connection, you should see a lock in your browser window, as well as "https" in the browser window.

- Consider making a secondary, disposable online identity with an incorrect address, phone number using a "free" e-mail account.

- Use a personal firewall program. Firewalls monitor both incoming and outgoing Internet traffic from a computer. This can protect the computer from being hacked into and block unauthorized programs—such as Trojans, worms and spyware.

- Five things to do if you pick up a virus or Trojan:

1) Install and/or update anti-virus and personal firewall software.

2) Update all virus definitions and run a full scan.

3) Confirm every connection your firewall allows.

4) If your system appears to have been compromised, fix it and then change your password again.

5) Check your other accounts. The Trojan may have accessed data related to accounts outside of your computer. Change passwords, etc.

PHISHING PREVENTION

- Be cautious about downloading any files from any e-mail you receive, regardless of who sent it.

- Be suspicious of any e-mail with urgent requests for personal information. Phishers include upsetting or exciting (but false) statements in their e-mails to get people to react immediately.

- Log in to bank and credit card accounts regularly and review statements to verify that no one is making unauthorized changes or purchases.

- Don't e-mail personal or financial information. E-mail is not a secure method of transmitting data.

- Don't click on links in e-mails from unknown senders. Instead, type in an address you know to be authentic or call a company phone number that you have called before.

- Forward the complete fraudulent e-mail (with header intact) to a company being used as a front in a phishing scam.

- Keep software (operating systems and browsers) updated. Crooks and hackers are continually finding vulnerabilities in software operating systems and Internet browsers. Software vendors are constantly updating their software to fix these vulnerabilities.

- Phishing e-mails are almost always *not* personalized, while legitimate messages from your credit card company or bank Web sites usually will be. Learn to tell the difference.

- Use anti-spyware/adware and anti-virus software. And keep these up to date. Some phishing e-mails contain software that can track your activities on the Internet without your knowledge.

AVOIDING MALICIOUS SPAMMERS

- Never purchase spam-advertised products. Aside from encouraging the spammers, this also makes more of your personal information—name, address, phone number, credit card numbers, and the like—available to spammers.

- Never send personal information to e-mail requests. You should never be asked for a password, credit card number or Social Security number from a

legitimate source via e-mail. Beware official-sounding notices that require you to give up your personal information due to supposedly dire consequences.

- Beware of get-rich-quick schemes. This warning also applies to work-from-home "opportunities."

- Refrain from clicking on *Reply* or *Remove* links. Some senders may remove your address, but others may flag your e-mail address as live, and send you more spam or even sell the address to other spammers. Instead, you can forward spam to the Federal Trade Commission at uce@ftc.gov.

- Use a public e-mail address when online. Set up and use a public e-mail address—either an additional address from your ISP or a free e-mail address. Use this e-mail address when participating in newsgroups or anytime that your e-mail is requested by a third party online.

- Don't post your e-mail address online. Before you post your e-mail address, know whether it will be displayed or used.

AVOIDING AUCTION FRAUD

- Find out what actions the Web site takes if a problem occurs and consider insuring the transaction and shipment.

- Learn as much as possible about the seller, especially if the only information

you have is an e-mail address. If it is a business, check the Better Business Bureau where the seller is located.

- Examine the feedback on the seller and use common sense. If the seller has a history of negative feedback, avoid that person or firm.

- Determine what method of payment the seller is asking for and where he/she is asking to send payment. Use caution when the mailing address is a post office box number.

- Be aware of the difference in laws governing auctions between the U.S. and other countries. If a problem occurs with the auction transaction that has the seller in one country and a buyer in another, it might result in a dubious outcome leaving you empty handed.

- Ask the seller about when delivery can be expected and warranty/exchange information for merchandise that you might want to return.

- Never give your Social Security number or driver's license number to a seller. Sellers have no need for this information.

- Seven steps to take if you've been ripped off by a crooked seller:

1) File a complaint with the online auction company. In order to be considered for eBay's Fraud Protection Program, you should submit an online

Fraud Complaint at http://crs.ebay.com 30 days after the listing end-date.

2) Contact law-enforcement officials at the local and state level (your local and state police departments).

3) Also contact law-enforcement officials in the perpetrator's town and state.

4) File a complaint with the Internet Crime Complaint Center (www.ic3.gov).

5) File a complaint with the shipper or the U.S. Postal Service (www.usps.com/websites/depart/inspect).

6) File a complaint with the National Fraud Information Center (www.fraud.org/info/contactnfic.htm).

7) File a complaint with the Better Business Bureau (www.bbb.org).

AVOIDING INVESTMENT FRAUDS

- Do not invest in anything based upon appearances. Just because a person or company has a flashy Web site doesn't mean it is legitimate. Web sites can be created in just a few days. After a short period of taking money, a site can vanish without a trace.

- Investigate the individual or company to ensure that each is legitimate.

- Check out other Web sites regarding this person/company.

- Be cautious when responding to special investment offers (especially through unsolicited e-mail) by fast talking telemarketers.

- Inquire about all the terms and conditions dealing with the investors and the investment.

AVOIDING NIGERIAN 419 SCAMS

- Be skeptical of individuals representing themselves as Nigerian or other foreign government officials asking for your help in placing large sums of money in overseas bank accounts.

- Do not believe the promise of large sums of money for your cooperation.

- Do not give out any personal information regarding your savings, checking, credit or other financial accounts.

- Do not advance any money against cash to be received later.

- If you are solicited, do not respond and notify the appropriate authorities.

OTHER INTERNET FRAUDS

- Remember: No complaints does not mean a seller or company is legitimate. Fraudulent operators open and close quickly, so the fact that no one has made a complaint yet doesn't mean anything.

You still need to look for other danger signs of fraud.

- Don't believe promises of easy money. If someone claims that you can earn money with little or no work, get a loan or credit card even if you have bad credit or make money on an investment with little or no risk, it's probably a scam.

- Resist pressure. Legitimate companies and charities will be happy to give you time to make a decision. It's probably a scam if they demand that you act immediately.

- Beware of imposters. Someone might send you an e-mail pretending to be connected with a business or charity, or create a Web site that looks just like that of a well-known firm.

- Don't provide your credit card or bank account number unless you are actually paying for something.

- Beware of "dangerous downloads." In downloading programs to see pictures, hear music, play games, etc., you could download a virus or connects your modem to a foreign telephone number, resulting in expensive phone charges. Only download programs from Web sites you know and trust.

- Read the user agreements, licenses and other contracts before clicking through to the information or activity you seek. Really. They're not all the same.

INDEX